Half-Life of a Dream

Half-Life of a Dream:
Contemporary Chinese Art

from the Logan Collection

Jeff Kelley

Christoph Heinrich

Eleanor Heartney

Kent Logan

San Francisco Museum of Modern Art

University of California Press
Berkeley Los Angeles London

On the cover:
SUI JIANGUO [隋建国]
The Sleep of Reason, 2005
see also pls. 18–21
Collection of Vicki and Kent Logan

Preceding pages:
LIU WEI [刘炜]
Swimmers, 1997
detail of pl. 57
Collection of Vicki and Kent Logan, fractional and promised gift to the San Francisco Museum of Modern Art

This catalogue is published by the San Francisco Museum of Modern Art in association with University of California Press on the occasion of the exhibition *Half-Life of a Dream: Contemporary Chinese Art from the Logan Collection,* organized by Jeff Kelley for the San Francisco Museum of Modern Art and on view July 10 through October 5, 2008.

Support for the catalogue has been provided by Sotheby's.

Director of Publications: Chad Coerver
Managing Editor: Karen A. Levine
Designer: Bob Aufuldish, Aufuldish & Warinner
Publications Assistant: Amanda Glesmann

University of California Press
Berkeley and Los Angeles, California
University of California Press, Ltd.
London, England

Cataloging-in-Publication Data for this title is on file with the Library of Congress

ISBN 978-0-520-25779-5 (cloth : alk. paper)

Printed and bound in Italy by Graphicom.

Throughout this publication, the names of Chinese artists and other historical figures are presented according to Chinese convention, with family names preceding given names.

17 16 15 14 13 12 11 10 09 08
10 9 8 7 6 5 4 3 2 1

Photography Credits

Unless otherwise indicated below, all illustrations were provided by Vicki and Kent Logan and are reproduced by permission of the artists or their representatives.

Cover: Seng Chen, © Asian Art Museum of San Francisco. Used by permission.

Plates: 1–7, 9–13, 15, 24–25, 65–66: Jeff Kelley; 14: courtesy Yu Hong; 16: Qian Dongsheng; 17: courtesy Xu Bing Studio; 18: Jeff Kelley, © Asian Art Museum of San Francisco. Used by permission; 19–21: Seng Chen, © Asian Art Museum of San Francisco. Used by permission; 23, 32, 92: Jeffrey Wells; 26–27, 29, 53, 56–57: courtesy Vicki and Kent Logan and the San Francisco Museum of Modern Art; 30–31, 55: Jeffrey Wells, courtesy the Denver Art Museum; 47–48: courtesy Vicki and Kent Logan, reproduced by permission of the Denver Art Museum; 50–52: Ian Reeves, courtesy Vicki and Kent Logan and the San Francisco Museum of Modern Art; 59: Stefan R. Landsberger Collection, International Institute of Social History, Amsterdam, http://www.iisg.nl/~landsberger; 61: Luc Berthier; 63–64: courtesy Schoeni Art Gallery, Hong Kong; 69: courtesy Rena Bransten Gallery; 70–72, 86, 89–90: courtesy Galerie Urs Meile, Beijing; 73–79, 111–12, p. 82: Ben Blackwell; 80–85: Scott Stohler, courtesy Rena Bransten Gallery; 88: courtesy Alexander Ochs Galleries, Berlin; 94–95, p. 126: Ben Blackwell, courtesy San Francisco Museum of Modern Art; 102: reproduced by permission of the Denver Art Museum; 105–6: courtesy Haunch of Venison; 107: Gao Minglu.

Contents

Director's Foreword

Neal Benezra

In November of 1997 Vicki and Kent Logan acquired their first works of contemporary Chinese art. Made by Fang Lijun in 1990–91, the two paintings—the disconcerting grisaille portraits of youths at the seashore pictured on pages 58–59 of this catalogue—embodied the Chinese people's profound frustration and disillusionment in the wake of Tiananmen Square. Provocative at the time, the works are now internationally recognized as icons of the Chinese art movement known as Cynical Realism. And the Logans did not stop there. By 1998 they had acquired works by some of the most significant Chinese artists of our time, including Liu Wei, Liu Xiaodong, Yue Minjun, Zhang Xiaogang, and Zhang Huan.

It is impressive to realize that the Logans bought their Fang paintings only four years after they started collecting art—and nearly a decade before the West really caught on to the Chinese scene, most notably on the occasion of Sotheby's 2006 auction of contemporary Asian work in New York. Vicki and Kent have pursued their interest in Chinese art with the same intelligence, passion, and vigor that they bring to bear on the rest of their fine and wide-ranging collection. Today they own more than a hundred and thirty remarkable works by Chinese artists, having fully and fractionally gifted dozens more to SFMOMA and other institutions.

Half-Life of a Dream, which marks our seventh dedicated presentation of art from the Logan Collection, is a finely focused, up-to-the-moment survey of contemporary Chinese practice—and our museum's first sustained examination of Chinese art in nearly a decade. Spanning several generations and a number of eclectic styles, from the Political Pop of Yu Youhan (born 1943) to the as-yet-unclassifiable figuration of Zheng Li (born 1976), this carefully curated selection of paintings, sculptures, and installations offers an intimate glimpse of a nation as it struggles to reconcile the legacy of Mao with its current breakneck pace of modernization. With the Olympic Games scheduled to open in Beijing this August, the eyes of the world are on China as never before. SFMOMA is extremely proud to present this timely, thought-provoking, and pleasurable exhibition, thus fostering a deeper understanding of China's ever-evolving cultural milieu.

On behalf of the museum and the Logans, I must begin by thanking Jeff Kelley, a Bay Area critic and curator with invaluable expertise in contemporary Chinese art, for agreeing to serve as the exhibition's guest curator. His close relationships with many of the artists in the exhibition, as well as his exceptionally productive partnership with the collectors, have benefited this project beyond all expectation. Jeff was aided in his work by a core team

of SFMOMA staff members, including assistant curator Apsara DiQuinzio, who provided onsite administrative support for all facets of the exhibition. Ruth Berson, deputy director, exhibitions and collections, brought her expertise to bear on the many aspects of mounting such an ambitious presentation, with the capable assistance of Jessica Woznak, exhibitions coordinator, and Mia Patterson, exhibitions and installation design coordinator. Kent Roberts, exhibition design manager and chief preparator—together with senior museum preparator Rico Solinas, exhibitions technical manager Steve Dye, and exhibitions technical assistant Joshua Churchill—oversaw all details of the exhibition's installation. Michelle Barger, deputy head of conservation and conservator of objects; Paula DeCristofaro, conservator of paintings; and Olga Charyshyn, registrar, exhibitions, deserve thanks for their painstaking care of the paintings, sculptures, and other diverse artworks in the collection. We also wish to acknowledge Sophine Lim, graphic designer; Jennifer Mewha, director of institutional giving; Stephanie Pau, manager, interpretation; and Robyn Wise, senior public relations associate, for their crucial contributions to the project. All of us at SFMOMA are indebted to Robyn Wiley, the Logans' collection manager, for her efforts on behalf on the exhibition and catalogue.

Documenting the exhibition and offering fresh critical perspectives on contemporary Chinese art, this handsome catalogue was produced under the guidance of managing editor Karen Levine, with invaluable input from Chad Coerver, director of publications, graphic design, and web, and publications assistant Amanda Glesmann. Support for the catalogue was generously provided by Sotheby's. Thanks are due to Jeff Kelley, Christoph Heinrich, Eleanor Heartney, and Kent Logan for their original contributions to the catalogue, and to Bob Aufuldish, principal of the graphic design firm Aufuldish & Warinner, for his distinctive work and unflappable good humor. Translator Ling Chen Kelley kindly provided the Chinese characters used in this volume and the exhibition. The book was published in association with University of California Press, and we are tremendously grateful to Deborah Kirshman and her colleagues for their early support of the project. The publications team would also like to thank photographers Ben Blackwell and Jeffrey Wells and the folks at Ship Art International—particularly Phillip Schubert in San Francisco and Heather Sheldon in Denver—for their assistance with last-minute photography.

An exhibition of this scale and ambition would not have been possible without the participation of the artists, whose work and ideas inspired this project in the first place. A number of them welcomed Jeff and his wife, the painter Liu Hung, into their studios over

the past year, offering a view of current projects and sharing a wealth of insights into the social, economic, and political context of their work. As Jeff points out in his essay in this volume, many of these artists have produced work in the face of considerable political and creative oppression, and one can only admire them for their courage and accomplishments. We extend deep thanks to them and to their gallery representatives, who have been extremely helpful in attending to the many details involved in this undertaking.

On a final note, SFMOMA's Board of Trustees joins me in thanking Vicki and Kent Logan for their longtime support of our institution. They have been ideal collaborators on so many projects over the years, and we are exceedingly grateful for their thoughtful, opinionated, responsive, generous, and ongoing patronage. One of the primary motivations behind their collecting practice has always been to make their holdings accessible to the widest possible audience, and it is our great mutual pleasure to share this world-class collection of Chinese art with the San Francisco Bay Area and beyond.

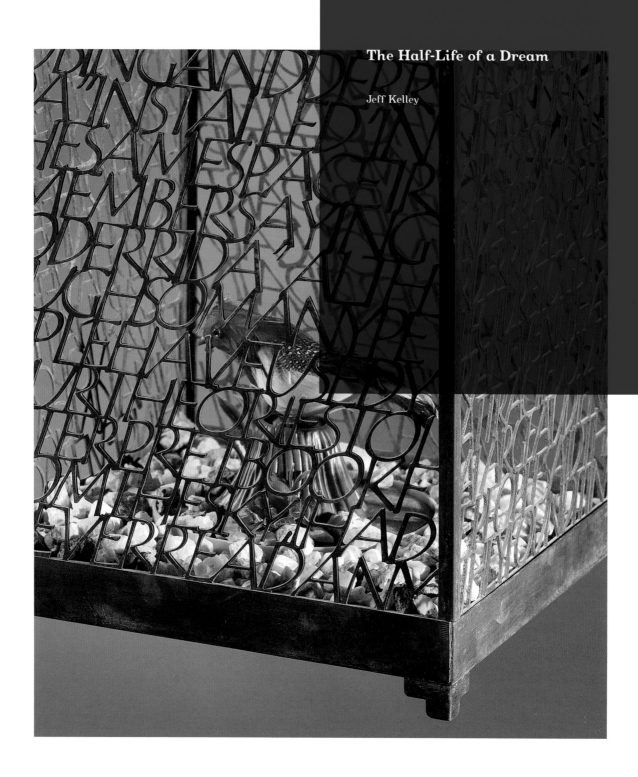

The Half-Life of a Dream

Jeff Kelley

In 2005 the sculptor Sui Jianguo completed a monumental work called *The Sleep of Reason* (pls. 18–21). It depicts a prone Mao Tse-tung, lying on his side and covered in a blue, floral-patterned peasant blanket, asleep atop an undulating landscape of twenty thousand luridly colored plastic toy dinosaurs. Arranged in masses by kind, and thus by color, the reptiles form a landscape of roiling, tsunami-like wave patterns that from a distance resemble the continent of Asia and up close look like snapshots of hell as perpetual revolution—especially the red dinosaurs. Slumbering serenely above this panorama of epic, violent struggle, like the sleeping Buddha gently departing his mortal shell and entering nirvana, is Mao. Cast in fiberglass and resin, this Mao is not carved from Socialist Realism's official lexicon of poses for depicting the omnipotent Chairman, but is fashioned instead in the colorful, simplified, nonnaturalistic manner of rural Chinese folk art. • *The Sleep of Reason* marks the first instance of a contemporary Chinese artist portraying Mao's likeness on its side. The only other

place Mao has been seen this way in public is in his mausoleum in Tiananmen Square, where his body has laid in state since 1977, a year after his death. In both cases Mao's face is the color of a ripe peach (a folkloric symbol of longevity), reminding us that in his lifetime he was hailed by millions as the "Reddest Red Sun." Like an ancient sign from heaven we can still witness, the setting sun in Beijing today is breathtaking, but its reddest red redness is more a result of auto emissions, industrial pollution, and the city's omnipresent dust than the fading glow of Chinese Communism's ideological half-life—although one feels it must be that as well.

By depicting Mao lying down, Sui, who was born in 1956, was putting the Chairman of his psyche to rest. Like Francisco de Goya's famous etching of the monsters that haunt the darkness of an artist's imagination, *The Sleep of Reason* depicts Mao's dream of China as a state of fitful turbulence both destructive and creative, unleashing the demons of the irrational that underlay the Marxist logic of progress (which was itself a dream). Mao's little sleep also suggests an ironic variation of the Buddha's detachment—an emperor's indifference. Widely noticed within the contemporary Chinese art world and beyond, *The Sleep of Reason* brought crisply into focus a theme common among artists of the post-1985 avant-garde: their personal dream states of the collective state dream.

In part, Maoist China dreamed itself through the brushes and chisels of its artists. They rendered Mao's vision of a Chinese-style Communism in collectivist, utopian terms: rosy-cheeked peasants harvesting the land's bounty, noble factory workers feeding the furnaces of the future, heroic soldiers sacrificing their lives for the Revolution, and, of course, idealized portraits of the Chairman himself. In revolutionary China every face, it seemed, was Mao's. It represented the fusion of countless idealized workers, soldiers, peasants, and children in the single countenance of a nation. Art under Socialist Realism was single-minded and ideologically focused. So was the state dream that art represented. Unlike the American dream, which is based upon the myth of the individual as the driving force of national identity (true or not, for better or for worse), the dream of China under Communism has been in the name of "the people" writ large, with individuals consigned to their fates. It had always been thus. To the extent that unification (of provinces, of language, of nationalities) has been China's dream for millennia, the collectivity of dreaming is as ancient as China itself.

But what happens to artists when their society suddenly wakes up from its leader's dream?

Chinese art in the decade after Tiananmen Square is often discussed in terms of the cynical reactions of artists to the political crackdown of 1989 and the emerging consumerism of the time (Cynical Realism).[1] It is also understood as a largely ironic reaction to the academic patriotism of Socialist Realism (Political Pop). With time, however, and despite the current market frenzy surrounding it, contemporary Chinese art—painting and sculpture in particular—has revealed itself to be more psychologically resonant than the facade of Pop iconoclasm and gestures of ironic detachment might readily suggest. Behind that facade, and in the wake of those gestures, lies a dreamscape whose masks, shadows, ghosts, reveries, muteness, suffocations, erasures, self-sacrifice, ruins of body and history, confrontations with power, and exposed psychic skin settle naggingly into our heads. The psychology of contemporary Chinese art lies postfascia, behind closed eyes.

Perhaps the parade of self-portraits we have come to associate with the emergence of vanguard art after Tiananmen Square misdirected us with the appearance of irony. At the same time, misdirection in China is often a mask that signifies what cannot be said directly. This is not only a question of political expression, but also of artistic expression. The Western tradition of self-portraiture tends to involve an artist locking eyes with the viewer through the medium of self-representation. The artist's image is self-reflexive, as if captured in a mirror or a lens. We are invited to penetrate the artist's soul. By contrast, the self-portraits (both early and recent) of artists such as Fang Lijun, Yue Minjun, Zhang Xiaogang, Zeng Fanzhi, Yang Shaobin, and Zhang Huan—among the most recognizable Chinese artists to Western audiences—tend to deflect emotional contact with the viewer through contorted or dimwitted facial expressions; closed eyes; frozen smiles (or screams); static, lockstep, or slapstick poses; affectless blank stares or masks; or blurred (even bloody) features. Frustrating our desire to see into the artists' souls, these self-portraits reenact the psychic aftermath of an era in which representations of specific human emotions were replaced with the idealized faces of the Revolution.

Today the faces of leaders, soldiers, workers, and peasants—even Mao—have been replaced by those of crazy, delirious, mute, eccentric, and menacing postrevolutionary artists. Twisting the Chairman's Buddha-like calm into expressions of deadened detachment, near lunacy, or even self-caricature, the artist's face has come to signify the missing emotion of the once-Orwellian state. Moreover, these self-presentations are not addressed to the psyche of the individual viewer, but rather to the collective consciousness of the crowd (the legacy of art for the people). The psychological divide they articulate is that which lies

between self-portraits and masks. One might think, for example, of Fang's lunatic grimaces, Yue's painted smiles, Yang's howling mutations, Zeng's furtive flirting, Zhang Xiaogang's stoic gazes, Liu Wei's comical grotesquery, and Zhang Dali's "death masks" of migrant workers as contemporary variations on Peking Opera. Behind the masks is the common (dare we say collective?) dreamscape that is still being conjured by Sui's sleeping Mao.

The half-life of that dream—the time it has taken for Mao's psychic body, still warm to the touch, to cool—is the period in which contemporary Chinese art has come of age. If China confronted the West geopolitically during the Cold War, Chinese artists have confronted the geocultural nexus (the United States and Europe) of international modernism since 1989. Though China tried desperately under Mao to modernize, it never really had a cultural—much less artistic—modernity (save Marxist ideology). Its aesthetic great leap was from Socialist Realism to a vague idea of global postmodernism—in theory, at least. Meanwhile, from the New Wave of 1985 through the 1990s the homegrown urgency of Chinese artists was the overthrow of official art—and thus a shift from illustrating the state dream to developing distinct personal styles. This was a psychological revolution in which a collective hallucination gave way to the ghosts in each artist's head. It was an awakening both gradual and fitful. As with any powerful dream, however, the emergence of contemporary art in China has the feel of hypnagogia, the state between sleeping and waking in which the remnants of a dream and the first light of morning commingle. It can be difficult to tell the difference.

Liu Xiaodong's *Xiaomei* (2007; pl. 28), named after the model he painted, is a meditation on hypnagogia. As the nude model lay back sleepily in the studio, her drifting in and out of consciousness gave the artist his reason to paint her. She seemed to him a metaphor of the ideal creative state: the painting, like the model, was open to influence. A languid and bittersweet air suffuses the picture. At the top of the canvas Liu squeezed oil pigment directly onto the surface, from which he mixed the colors to render Xiaomei. Her image is formed from the ground of her own mixing; the canvas is its own palette. Beneath her appear a scattering of personal accessories—a tube of lipstick, a cell phone, a perfume bottle, a small Louis Vuitton purse—that are the cosmetic equivalents of the patches of color above. She lies suspended between the raw materials of painting, which dream her as an image, and the refined products of feminine adornment, which she is dreaming in turn. The question arises, and it is an ancient one in China: who is dreaming whom?

The Chinese philosopher Zhuangzi, who was likely born in the fourth century BCE, more than a century after the death of Confucius, tells a famous story, "The Butterfly Dream."

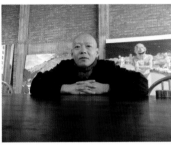

plate 4
Yue Minjun in his studio near
Beijing, 2007

plate 3
Zhang Xiaogang in his Beijing
studio, 2007

It opens:

Once upon a time, Zhuangzi dreamed that he was a butterfly, flying about enjoying itself. It did not know that it was Zhuangzi. Suddenly he awoke and veritably was Zhuangzi again. He did not know whether it was Zhuangzi dreaming that he was a butterfly, or whether it was the butterfly dreaming that it was Zhuangzi.[2]

This is among the classic conundrums of Chinese consciousness. Who is the dreamer and who is the dreamed? The dreaming represented by Zhang Xiaogang, Yue Minjun, and Fang Lijun poses these very questions. By painting their own faces they raise the psychological stakes, risking getting lost behind a signature stare, smile, or grimace—especially if it seems like these signature expressions have been painted a thousand times. In the aftermath of Socialist Realism's conformity, however, the development of personal styles was liberating, indeed revolutionary, for artists. Personal styles replaced the official style. Famous artists became the party leaders of the Chinese avant-garde.

Zhang Xiaogang believes that in China an individual cannot separate from the nation's fate. Thus, an American-style dream is unthinkable there. Having grown up in the idealized dreamworld of Socialist Realism, and having first encountered Western art (examples of Impressionism and Surrealism) in 1979, Zhang feels that China is still caught in a cultural jet lag—a kind of half-dream state. He cites three periods in the development of contemporary Chinese art from 1980 to the present: absorbing Western influence ("catching up like crazy"), however unselectively ("after a famine, you eat anything"); seeking a personal idiom while simultaneously learning to have a dialogue with the Western art world; and managing a career in today's market for Chinese art ("the market is a dream; the new dream is numbers").[3] Having passed through these three phases, Zhang regards the realities of Maoist China as a kind of hangover. The artist feels he must be alone in the studio to paint his softly surrealistic portraits (see pl. 26) of stiffly posed people with affectless faces and big, welling dark eyes (a contradiction brimming with repressed feeling). "The process of making art," he says, "is like dreaming a dream." Look closely at the surfaces of his canvases and you will see that his dreamscapes are whetted by his taste in paint, which he softly brushes across the faces of his subjects with the knowledge that, except with the mineral pigment, he can never really touch them.

Yue Minjun, whose paintings (pls. 29, 60) depict the artist at the center of various spectacles, often wearing only briefs, with his face contorted in a wide, frozen laugh (or is it a scream?), believes that the collective dream of the past was forced, unnatural. In Mao's time the Chinese did not know they were dreaming. He likes the idea of time (especially *that*

time) coming to an end, à la Salvador Dalí's drooping clocks. Yue likens the Chinese experience today to waking up from a dream whose details escape recall—one can only remember the now-hollow scene. Just so, the scenes he paints—with Yue clones marching, saluting, doubling over in (one hopes) laughter, and (most importantly) struggling—are like political spectacles or reenactments of art history, with the artist himself replacing the missing actors. His work represents two kinds of dreamscapes: those populated by empty figures (the clichés of Socialist Realism) and those bereft of psychic content (like surrealist art, Dalí's in particular). Mao and Freud, in other words, are the specters that haunt Yue's paintings.

The vocabulary of struggle that parades through Yue's work is sealed in its own dream space. The artist—for it is his face in the paintings, always the same—never makes eye contact with the viewer. We witness the spectacle, but the subject doesn't look back. Behind the artist's face, which is literally and figuratively the face of his painting, is the dream that he insists upon, over and over forever. It is the opposite of a nation's collective dreaming because it substitutes the propaganda of the self for that of the state. It is the self posed against the backdrop of a world that is not pretending to be real. As the backdrop changes from painting to painting, the artist gets to recompose himself again and again. The surrealist curtain that hangs between him and the viewer—a smooth, almost invisible scrim of absurdity—protects him from reality. In China artists must still be cautious about saying things directly, so they often depict themselves endlessly saying nothing, chanting or laughing into the chaos of the collective dreamscape.

Fang Lijun, another artist whose likeness has become part of the painted face of the new China, believes in the Taoist idea that, individually, one completes oneself. As this is traditionally achieved through study and self-cultivation, Fang's adherence to Taoist notions may seem surprising. He became famous for painting grimacing, shaved-headed, dim-witted hooligans that became the icons of mid-1990s Cynical Realism. Their pinched and yawning facial expressions bespoke a psychic numbness. Fang's paintings were the silent yowls of a country unable to mourn the tragedy of 1989 (which the artist personally witnessed). In one example (pl. 50), rendered smoothly in gray tones, several lunatics hang out at the ocean's (the world's, the psyche's) edge, eyes closed and mouths half-open, like lobotomized self-portraits. In another (pl. 52), a huge orange face, its mouth agape as if drowning, sinks beneath the surface of cerulean water.

Fang's work is different today: grandly ambitious, bizarre visions of heaven without any religious underpinnings. It is as though the mass mania of the Maoist era has become

unhinged in the wake of Mao's dream. These are dreams belonging solely to the artist: personalized rhapsodies in which boatloads of Chinese cherubs, like baby Fangs, drift to and fro. To Western eyes Fang's vision may represent an untenable expanse of ego. In China, however, it declares the terms by which contemporary artists must still assert themselves. The inflated space of the state dream—with its collective power and captive audience, its cast of repeated characters, its masked emotions and clichés of the self, and its comic-book narratives—must be punctured and inhabited by individual artists, even if repeating clichés of themselves ad infinitum (a veritable army of personal likenesses) is the price they must pay to hold the dreamscape until the future arrives. It is no longer the job of the state to complete "the people." The artist, taking refuge in the eccentric, elevated space of the ancient literati, must struggle to complete himself as an individual, even as his single subject—numberless iterations of himself—drifts in a sphere that is not yet of this earth.

The struggling human (or subhuman) figures in Yang Shaobin's paintings (see pl. 47) are less recognizable as self-portraits because they are obscured by the violence to which they seem destined, like Saturn eating his children or a host of apparitions tearing one another apart. Destruction is the creative impulse here, and what is being destroyed is the ghost of Mao, who clearly haunts the artist's memory. Painted with broad, layered, and often drippy, bloody swaths of red pigment, Yang's large canvases are expressionistic yet oddly muted and reserved. They do not scream at the senses, yet one feels the visual equivalent of muffled cries and distant howls. Paint, in this sense, is a material scrim that does not so much express an image as press back upon the surface of the panorama it represents. It breathes in, not out. Chinese artists seldom spill their guts; it is the political and historical context—the background, not the personal content—that is the degree zero of making meaning.

The emotional motivation behind Yang's work is the feeling of not being safe. In 1985, a factory worker, he did not get into Beijing's Central Academy of Fine Arts (and thus had no chance of being influenced by the New Wave movement of that time). Instead he studied applied arts in Hebei (at the same school as Fang); painted ceramics for seven years; moved (again, with Fang) west of Beijing (to Haidian, near Peking University), where they were chased out by police; and then moved east of Beijing (to Songzhuang, a farming village now famous for its prominent Chinese artists), where, in the wake of Tiananmen Square, there was no market, legal status, money, or tradition. He was an artist-hooligan who knew nothing and had nothing to paint. The New Wave movement of 1985 had truly been a movement, but after 1989 artists retreated into themselves. The only power an artist

had then was the knowledge of himself, the experience of his body, and the likeness of his face. Starting at zero.

Chinese artists are very self-reliant. Having cast off an oppressive academic tradition, they have had to be. They invented their own avant-garde and, in the early days, made art of their impoverished circumstances. There was no audience for their work, so they turned their faces toward the West, which has always wanted to see what China really looked like. More than politicians or the landlords of industry, artists showed the world that China was changing. Arguably, the likenesses of a corps of young Chinese painters—and their conceptual godfather, Ai Weiwei—are more familiar among educated audiences in the West than are those of China's top party leaders today. The constant exhibition of their works worldwide, and of lesser pieces that mimic their distinctive personal styles, resembles a political rally with posters of candidates pasted all over the art world (not to mention the arts districts of Beijing). In a sense, though, the mass attention lately given to a handful of Chinese artists, in conjunction with those artists' tendency to repeat their own likenesses, has obscured the personal courage, inventiveness, and dead honesty originally involved in painting oneself when there was nothing left to paint. By painting little dreams of themselves, vanguard Chinese artists filled up the gaping emptiness left behind in the square after 1989.

Self-portraiture starts with self-reflection (another experience of zero), with the painted canvas as the medium between the artist and the mirror. During the process of painting a negotiation unfolds in both directions, the resulting image being as much a psychic surface—a mask—as a representation from life. A mask is a shield that deflects the viewer's gaze. It seals the subject in a tight skin, be it a starched suit or a stretched canvas. The wearer sees the outside world yet feels the pressure of the mask against his face, and behind his face he feels the pressure of another world. A mask is not a window to the soul but a psychic membrane contoured to a likeness.

The wide-eyed male protagonists in Zeng Fanzhi's *Mask Series* are fitted with whitish disguises contoured to the artist's likeness. They wear crisply tailored suits and fidget uncomfortably with their overly large (not to say swollen) hands. In one painting (pl. 48) two masked men flirt stiffly, one holding (and seeming to offer the other) a red rose as they sit on a tidy blue bench against a powdery orange-pink ground. The body language between them speaks volumes about the formalities of coming out in China, if only in a painting (or in a painted dream). The man being offered the rose sits tight, his legs closed,

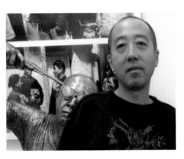

feet together, one arm across his lap and the other touching his mask/face in a gesture of coy embarrassment—but his smile is wide and his eyes connect with his admirer's. The latter, who holds the rose in his lap, is slightly more relaxed, his legs a bit open, his feet not quite together. He seems to have made a move (and thus awaits a reply), albeit one barely visible to the outside world. In traditional Peking Opera only men played women; this is a modern-day version enacted with masks and costumes. Zeng's same-sex intrigue, in all its gorgeous repression, smolders beneath the constrictive power of social norms in a culture filled with uncomfortably fitted suits.[4]

Zhang Dali casts the faces and bodies of migrant workers who flock to Beijing from the countryside (see pl. 55). His are death masks for a growing urban population that does not officially exist. Eyes and lips closed tight (to keep out the wet plaster the artist uses for the mold), the heads are cast in a clay-gray resin and wear expressions of sheer endurance and passive acceptance. Scanning the lineup, we seek recognition (a famous Chinese artist perhaps?), but a morbid anonymity drifts from face to face like a spirit that never quite coalesces into a likeness. Yet these hollowed skins have touched real people, young and old, men and women—the unacknowledged faces of China. Ever since the early 1990s, when Zhang began spray painting quick graffito outlines of a human head in profile (see pl. 66) on condemned *hutong* buildings (the brick, multifamily, interior-courtyard structures that are traditional to Beijing), his work has focused on the erasure of identity in the context of massive growth and displacement. Once idealized but now invisible, his subjects are the laborers of the new great leap forward—the working dead. They are apparitions in the new dream of China, but the dream is not for them. In this most dynamic of economies, they bear mute testimony to the ghost in the machine.

Ghosts, masks, self-reflections, recurring settings, large crowds: dreaming among Chinese artists has its subsets. Others are dismemberment and drowning. Sheng Qi, for example, who exiled himself from China after Tiananmen Square, is infamous for having severed his left pinkie, which he planted in a flowerpot and left behind in Beijing in order that a small piece of himself would forever remain in his homeland.[5] Fang, meanwhile, is known for paintings in which human figures are immersed or sinking in water. A reference to the content and surface of painting, water seems in Fang's work a primal, amniotic medium that parallels a dream in the way it both liberates and impedes the dreamer (imagine trying to run underwater). A metaphor for China's spiritual anomie in the wake of 1989, the image of water in the work of Chinese artists has ranged from blocks of ice to

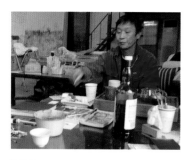

flowing rivers, from fish ponds to limitless oceans. It replaced the ground beneath their feet with a fluid and changing expanse, reflecting also, perhaps, the shift from academic to avant-garde painting.

Liu Wei's painting of two synchronized swimmers (pl. 57), both women, expresses the contradiction between lockstep uniformity and the dream of flight in a not-quite-zero-gravity medium (a dream of freedom?). His painting of two drunk artists (pl. 56), completed within a year of Tiananmen Square, suggests a liquid state of consciousness. With a menacing double portrait of Mao looking over their shoulders, the artists, side by side, seem to stagger under the intensity of his gaze. Their physical and psychic disequilibrium echoes the warble of drowning men. The decadence of drunkenness has replaced the dream of creative consciousness. The artists swim in themselves the way the swimmers dance in the water: both enact delirious performances in a liquid medium, gaudy and pathetic in their own ways. Liu is best at capturing the sort of moment when pose becomes pretense. Though he no longer paints like he did back then, now preferring as subjects the trees and fields (the solid earth) surrounding his Songzhuang studio, there has always been an urgency to his canvases that has made it seem as if each painting may be his last before he slips beneath its surface and disappears. Just to make a painting qua painting in China is freedom. But the past is always prelude, and while Liu is no longer interested in the cynicism and politics of the 1990s, the dreamscape of that period continues to nag the present. His synchronized swimmers, a critique of social uniformity and moral drift in 1997, have cycled back today like a ludicrous pair of mascots for the 2008 Olympics in Beijing. Meanwhile, the two drunk artists have likely sobered up and gotten rich.

Zhang Huan became famous in 1994 for *12 Square Meters,* a performance that involved sitting naked in a squalid public toilet for one hour; his body, covered in honey and fish oil, attracted flies like flypaper. At the time he was among a small group of Beijing artists living in what became known as the East Village, an impoverished encampment on the then outskirts of the city that reflected artists' marginalized circumstances in the aftermath of 1989. The performance made art of those circumstances and set the stage for the primary—and primal—leitmotifs of his career: physical endurance and ascetic detachment. Stoic and expressionless, his face is a psychological blank slate (upon which, for example, he has written his family history over and over in ink until his skin turned black), and his body, lean as a Buddhist monk's, is his instrument for self-awareness (as when lying nude on a bed of ice). Based on a spare choreography of ritual poses (mostly sitting, standing, and lying down)

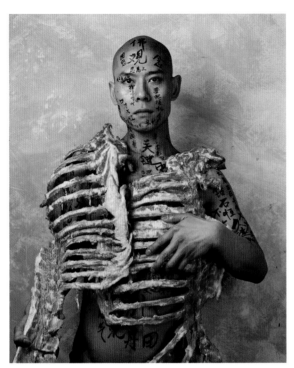

that feel generically Buddhist, Zhang's performances, and the sculptures and photographs they generate (see pls. 8, 67–68), embody a desire (perhaps the secret desire of every artist) to transcend material limitations. They are personal religious enactments but, like much modern art, they are not religion. Transcendence through physical discipline is a contradiction in terms, but in practice it is possible if exhaustion sets in. A physical threshold is necessary for transcendence, and thresholds of endurance are the arithmetic means of Zhang's work. He wants to leave his body without dying, like the sleeping Buddha entering nirvana. But Buddha left for good and his body stayed behind, becoming irrelevant. In attaining nirvana Buddha transcended the duality of life and death. Short of that, and in lieu of dying, Zhang will keep coming back to his upright body like a gyroscope regaining balance. His, after all, is the art of seeking passage while never passing away. His copper Buddha finger (pl. 106), about nine feet long as it lies on the floor (as the artist often does), is a reference to Buddha's being everywhere but where we seek him.

Art as physical endurance may or may not lead to transcendence, but it is clearly an enactment of one's limitations in life. The artist speaks not of having changed the world when he lay on a bed of ice, but of the ice (a frozen piece of the world) having changed him. How cold can I get? How stiffly can I hang from the ceiling? How many more fly bites can I take? Zhang makes elemental contact with the world through his body, and through that contact enters a dream state. "Buddhism," he says, "is just a dream—but it is a good dream."[6] In China ascetic suffering is associated with great ambition: to move a mountain or, as Zhang once tried to do in a performance, pull down a museum. The pathos of that ambition is that, no matter how determined, it is always only a parable, the lesson of a master. After Tiananmen Square, Zhang, as an artist, had only the medium of his body. So he sat alone in a toilet and helped change the corpus of Chinese art.

Ai Weiwei is the son of a famous Chinese poet, Ai Qing. Regarded by many as the finest modern poet in China, Ai Qing, who studied in France from 1929 to 1932, was exiled by Communist authorities to the remote province of Xinjiang in 1958 for suspected rightist

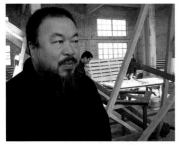

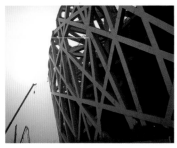

leanings. He was not allowed to publish his works, which involved modernist free verse written in a fervent political voice, until 1978, when he was officially rehabilitated by the party. In 1981 his son, having grown up in exile, further exiled himself to New York, where he experimented with performance art and Duchampian readymades but mostly observed the avant-garde scene until returning to China in 1993, when his father became ill. Like Ai Qing, Ai Weiwei was a modernist, and what he returned from New York valuing most was the freedom to do anything.

Today Ai Weiwei is widely regarded as the godfather of experimental Chinese art. In China no other artist is as influential. His Beijing studio, which he built in 1999 on land that is not legally leased, is a mecca to visiting curators, critics, architects, film crews, collectors, museum groups, and students. As an artist, architect, designer, curator, cultural critic, political commentator, and celebrity blogger, Ai is the Renaissance figure of the Chinese avant-garde. In terms of public notoriety he is China's Andy Warhol, but in terms of personal style he is a more complicated cross between Joseph Beuys and the sleeping Buddha.

A fervent modernist, Ai focuses his critique on power, whether embedded in the materials and traditions of the past or embodied in the politics and rhetoric of the present. When he dips Neolithic clay jars into buckets of industrial enamel, covering most of their ancient surface patterns with flows—and overflows—of designer pastel colors (see pls. 71–72), Ai neutralizes the authority of tradition, transferring the ancient artifacts' value—their aesthetic currency—to the contemporary objects they become for having been destroyed. Tradition, he believes, is renewed through destruction and disorientation. Staid objects spin out of control. A Ming Dynasty table, for example, is impaled by an enormous wooden column from a dismantled temple, tossing off an impossible balance in space that nonetheless stands as if captured in the instant of collapse. In a famous sequence of black-and-white photographs, the artist is shown indifferently dropping a Han Dynasty urn onto the ground, where it shatters. After the fall, his hands remain open, showing us nothing. "There are so many of these pots," he says, as if he had rescued the broken and painted vases from the crushing anonymity of being precious antiques.[7]

Ai is also famous for having designed, together with Jacques Herzog and Pierre de Meuron, Beijing's National Stadium—the "Bird's Nest"—another gloriously fractured vessel that is at the center of the early-twenty-first-century Chinese vortex. But just as he once dropped the priceless vase, Ai has already disowned the building, expressing disgust at the way the government is presenting it as a "pretend smile"[8] to mask political corruption,

economic disparity, and environmental degradation. He will not go near it, taking pleasure instead in having helped dream it up. It reminds him of the first time that, as a boy, he saw Tiananmen Square: having seen it a thousand times in pictures and movies, he had thought it would be bigger. Disappointed by the limits of its material reality, he thereafter preferred the idea of it to the real thing.

For Ai, being an artist is a self-generating activity. The paradox, he says, is that living your life as an artist requires a detachment from what you produce. Apropos of the Bird's Nest, he has never been to a sports arena and is uninterested in technical matters vis-à-vis architecture. He was attracted instead to the possibility of wholeness, envisioning a place undivided by engineering into parts. With the stadium, there is no hierarchy in the matrix. Each spectator will feel that she is in the same place as everyone else. It is a truly democratic public space—the opposite, ironically, of such places under Mao. At those sites of enforced uniformity, party leaders viewed and addressed the masses. Here, there are no masses, only individuals sharing a common place. There is, in a real sense, no architecture; architectural language disappears into the weave of the structure. The image of the structure—its wholeness—renders any pretense about architecture (style, surface, design) moot. A vision of place illuminates the architecture from the inside; a lightness is visible from the outside. Architecture is dematerialized as such, replaced by the tectonics of nature wrapped in an intellectual embrace.

Though he denounces its appropriation by the central government, Ai understands that the Bird's Nest will be—and may already be—the most visible work of architecture on earth. "China is very innocent," he says. "They don't know what they're building—like a fifteen-year-old boy who does something so important for the rest of his life but doesn't know what he is doing."[9] Ai wants to keep the image fresh in his mind, like the Tiananmen Square of his boyhood. Thus his refusal to go see the stadium is meant "to show [the government] what arrogance is." Arrogance, in this sense, is neither a superior stance nor an indulgence, but rather a choice *not* to associate with the common value system. Ai's attitude is the most important thing to him—a matter of urgent reality, not a pretense. "From time to time," he says, "you just have to announce it."

Ai is an anticlassicist in the sense that he makes ideas, but not ideals, manifest in material terms. The ideas he likes are usually preposterous ones: bringing 1,001 Chinese citizens to Kassel, Germany, for *Documenta 12*; designing a stadium from strips of cut paper; photographing nearly everyone he meets and nearly everything he does every day (for his

blog); ordering massive porcelain bowls from Jingdezhen (once home to the imperial porcelain factory) and filling them with thousands of pounds of freshwater pearls; and—in his restaurant in Beijing—stuffing his mouth, nostrils, and eyes with as many cigarettes as can fit, resulting in a grotesque yet slapstick portrait that blends themes of censorship, torture, and pollution (Ai does not smoke). His best works, be they sculptures, architecture, photographs, performances, or writings about art or politics (he has penned more than a hundred and fifty commentaries), turn preposterous ideas into elegant matrices of matter and mind or into stunningly iconoclastic images. Beyond the pleasure he takes in thinking them up, all the artworks he leaves in his wake may rightly be thought of as ruins. "I am a ruin of this society," he says. Nonetheless, a palpable presence of mind that insists upon its autonomy in the material world is the medium in which Ai's ideas spin forth.

There are two kinds of ruins: those we look back upon with longing (Romantic ruins) and those all around us that we never see (the underside of modern progress). In big Chinese cities zones of social and psychic displacement coexist with countless construction sites. Itinerant workers from the countryside, who are erecting China's new metropolises but have no legal status there, are like ghosts caught in the wrong tense, helping to build the future before returning to the past. This sense of temporal displacement pervades the Chinese psyche.

Li Dafang's **paintings** (pls. 89–90) depict exhausted landscapes, mostly crumbling urban settings but occasionally an abandoned agrarian expanse, in which anonymous human characters scratch away at unseen tasks for no discernable purpose. Often squatting or working in holes, they seem to be engrossed in tiny acts of survival, picking through the ruins of demolished buildings, vacant factories, or untended fields. Men or women, they never show us their faces. Though painted in a sharp visual key (usually with a palette knife), they look like apparitions in settings that pay them no heed. When there is more than one of them in a composition, something of a plot ensues, but it never moves beyond a vague encounter. This is the land of dreaming, in which the context is vivid but the particulars are hard to grasp.

In Yan Lei's paintings the context seems to be missing. His images—pictures of empty spaces, everyday objects, even color wheels—feel alien and bereft of meaning. Though based on photographs, they are neither grounded in the everyday world nor fixed in the emulsion of paint. Processed using computer software, Yan's pictures are broken down according to color saturation, resulting in a kind of chromatic topography (a paint-by-numbers rationalism) that retains the objective look of his source photographs while remapping them in

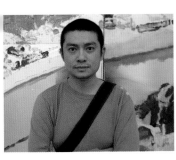

plate 12
Li Songsong in his Beijing
studio, 2006

paint. Yan has described painting as the mindless representation of an image one might see in a photograph—the inverse of self-expression. It is as if he were mentally processing the idea of painting through photography, and the idea of photography through painting.

In this sense Yan's paintings represent a form of conceptual art. Screened through the visual fields of painting and photography, they are essentially neither, coming together instead like mental pictures—indeed, his paintings look like thoughts. As such, one thought leads to the next. A barren expanse of Beijing under construction (pl. 91), for example, immediately brings to mind preparations for the Olympics. On one panel of a diptych (pl. 92), a Chinese man and woman with their faces painted like dogs crawl out the doorway of a New York department store, a handbag dangling from the woman's mouth. Beside them we see Sotheby's, New York. Called *Super Lights—Dog Year New York,* the painting refers to the auction house's first, and incredibly successful, international sale of contemporary Chinese art in 2006, the Year of the Dog. Once we understand the contexts of these paintings, they begin to make sense as evidence of an extended investigation into the inert spaces of the art world. Yan's works map the surfaces of an alienated photographic record of that world—they are image topographies with quivering chromatic contours, like the wavelengths of a low-grade aura. They are the null and empty dreamscapes of the market.

In an age of mass-media images, we tend to see history as a visual field—as pictures. Compressed together as journalism and driven forward by advertising, these pictures are part of a continuous screening of the day's events against the backgrounds of our minds. This relatively new form of cinema—the flow of images everywhere and all the time—has taken over the grand mythological narratives of progress, revolution, heroism, tragedy, and love that once belonged to history painting.

Li Songsong's works, cinematic in scale and thickly slathered with pigment, reverse the equation, bringing paint to the forefront and placing the pictures of history in the background. It is as if he were painting on paint, not canvas. Drawn from mass-media photographs, television, or newsreel footage, his subjects—images of political rallies, an assembly of diplomats at the United Nations during the 1962 Cuban Missile Crisis, the rolling out of a new Chinese missile (pl. 86), parades, public executions (pl. 87), and state funerals—seem exhumed by the artist's brush (and knife) from beneath layers of mineral pigment.

Li's paintings embody a material reality that supplants the immateriality (and the often staged unreality) of his source images. It is as if the once-spectacular subjects of Socialist Realism, buried here under layers of paint, have only partially bled through to

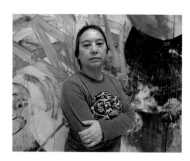

the surface—like stains or rubbings from the recent past. Despite the sensuousness of his surfaces, however, Li's hand is cool—almost detached—as it lays down paint with a brush or cuts images from its layers with a palette knife. His intensity as a painter seems unemotional (aesthetic intensity and emotion are not the same), but he is deeply attentive to the activity of painting. Pictures of history emerge from the background almost as afterthoughts.

Li's detachment from the images of history belies his position as a member of a generation that was relatively unexposed to mass politics during the era of Mao. For younger Chinese the films, spectacles, parades, rallies, public executions, and forced marches of revolutionary China are more a matter of history—mere images—than experience. Like a fading ideological background, mediated images of the collective past are replacing the actual, lived experience of historical events. They constitute the collective dreamscape from which Li's generation is awakening. For older Chinese those images remain psychic touchstones for personal memories (and nightmares). Perhaps what matters is not what Li's paintings represent about history, but what people who see his paintings remember, if anything, about their own experiences.

Liu Hung remembers. Born in 1948 and sent to the countryside for four years during the Cultural Revolution, Liu, who emigrated to the United States in 1984, came of age in China before there was a Chinese avant-garde. Older than all but a few of the first generation of contemporary artists, she represents a perspective based in personal and family experience that takes in the whole of postrevolutionary Chinese history. Her story is well known: her father, an officer in the Kuomintang (the Nationalist Party), was sent to a labor camp when Liu was an infant, and she did not see him again until she was forty-six. She traveled alone from northern China to Beijing when she was only twelve; was "reeducated" during the Cultural Revolution; painted furtive landscapes—not propaganda—in the early 1970s; was trained and then taught at the Central Academy of Fine Arts in Beijing, where she became famous for painting an exotic, nonproletarian mural (since destroyed); came to America and studied with Allan Kaprow at the University of California, San Diego; was embraced by American feminists in the context of late-1980s multiculturalism; and so forth. But as a woman she has often had her personal story told at the expense of her art.

Liu is mostly known for paintings based on historical photographs of nineteenth-century and prerevolutionary China: images of prostitutes, refugees, street performers, soldiers, and prisoners washed in veils of dripping linseed oil that, as she once remarked, "both preserve and destroy the image."[10] Preferring to work from black-and-white photographs

that are grainy and difficult to read, Liu liberates her subjects from the gray tones of the past by bringing them vividly to life as painted images. In the process of turning old photographs into new paintings, she often inserts traditional motifs from Chinese "bird and flower" painting, Buddhist iconography (from the ancient Mogao caves in Dunhuang, for instance, where she conducted research in the late 1970s and met the young Ai Weiwei), or calligraphy, as if to comfort the cataclysms of the present with the wisdom of the past.

Defying her training in Socialist Realism, Liu's innovation as a painter has been to erode her own technical mastery using a combination of oil washes and loose, painted circles (brushstrokes turned back on themselves, like Zen calligraphy). Historical memory (the subject) dissolves into the visual field; images struggle to remain on the surface but, as paint, they cannot resist the gravity of the oil that cuts through them as it slowly drains downward along the cotton weave of the canvas.

Though she has often painted pictures of Chinese in America, and while much of her personal story is that of an American immigrant, Chinese history has always been the essence of Liu's work. Recently her focus has shifted to *Daughters of China* (2006; pls. 80–84), based on a well-known propaganda film from 1949 that she remembers seeing as a child. It depicts an actual 1938 event in which eight female soldiers fighting the Japanese staged a rear-guard action that allowed the Chinese army to escape. Cut off with their backs against a river, they were coaxed to surrender by the Japanese once their opponents realized they were women. Rather than capitulate, the eight young soldiers—ranging in age from thirteen to twenty-eight—carried their dying and wounded into the river and drowned.

We Have Been Naught, We Shall Be All (2007; pl. 85), a painting whose title is taken from "The Internationale" (the worldwide Communist anthem), is a triptych showing a sequence from the film in which several women carry a comrade riverward. It recalls the Pietà in its limp pathos. Liu's runnels of dripping paint enact her subject: the figure struggling to stand but draining away. The metasubject here is the disembodiment of Socialist Realism; the artist bleeds dry its propaganda to reveal a narrative of common courage with women as its heroes.

Feminism was part of the state dream of Mao's China. The purported equality of women during the Maoist era was founded on the repression of sexual difference. Clothing was rendered asexual, emphasizing military, peasant, or worker status. Since then, images of women in Chinese art and film have been caught between a kind of Maoist butch masculinity, in which women impersonate the dress and actions of male revolutionaries and soldiers (the

women are rhetorically neutered, like double eunuchs), and a suffering, melodramatic femininity, in which pretty women bear, apolitically, the burden of a nation's repressed emotions. Liu's subjects over the past twenty years, from prostitutes to soldiers, can be understood as reflections of her struggle as an artist to find dignity in the face of every woman she paints. State feminism and exotic femininity must be reconciled, if at all, one painting at a time by an artist—a woman—free to identify with the underlying spirit of both. What Liu has always found beneath the fading surfaces of the photographs she studies are the ghosts that emerge from the prolonged act of respect she offers by painting them. There is only one face that has never risen out of the past for her, and that is Mao's. Liu remembers all too well what he looks like. She seldom renders his portrait, but when she does, as in the little canvas antiportraits of *Where Is Mao?* (1989–2000; pls. 73–79, 111–12), she draws his face—or rather erases it—with the back of her pencil.

Yu Hong is known for narratives of women that run parallel to the larger story of China since the Cultural Revolution. In a series of annual paintings documenting the events of her own life, newsworthy benchmarks such as the death of Mao, the trial of the Gang of Four, a major earthquake, and Tiananmen Square coexist alongside personal milestones: a childhood dream of becoming a revolutionary heroine, dancing in a ballet, having a picnic with her future husband (Liu Xiaodong, whom she met at the Central Academy of Fine Arts), getting married in New York, becoming pregnant, giving birth to a daughter, and so forth. In China history is still the master narrative behind everyone's personal story.

A series of large acrylic paintings called *She* shows women as gymnasts, real-estate agents, students, and parking-garage attendants—distant echoes of the heroic mothers, daughters, farmers, and factory workers of Socialist Realism, updated with modern settings, dress, and postures. Each painting is based upon a photograph taken by the artist of her subjects, usually showing them posing at work or at home. Juxtaposed with these painted portraits are equally large color photographs of the same women staging themselves in front of their own cameras. Since Yu never sees the women's snapshots before she paints her own pictures of them, the contrast between the two is always unexpected—a kind of semiotic disconnect among different presentations of and by the subject. In *She—White Collar Worker* (2006; pl. 93), for example, a mother and daughter are painted sitting on the couch watching television in their shared, cheerfully colored apartment. The glassy-eyed gaze of the daughter is completely absorbed in the television's glow, which bathes her in the psychic equivalent of a spotlight. Sitting next to her but slightly behind, the mother is literally overshadowed

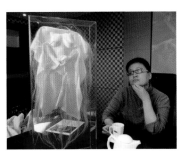

by her daughter. Meanwhile, the photos they supplied to the artist show the daughter posing like a magazine beauty in front of a cheesy painted backdrop of an ersatz Chinese village and the mother standing next to a statue of a horse-drawn Manchurian warrior at a tourist site. They are tourists in dreams of themselves.

Tiananmen Square was an example of public dreaming. In the aftermath of the crackdown, Lin Tianmiao began wrapping string around common household items like bicycles and end tables, seeming to refer to the binding of bodies and spirits. Her art was a kind of private dreaming, an alternative to reality. Since that time Lin's focus has deepened from the shared experience of social and political repression to the personal experience of self-revelation. Known for a body of work that reveals a kind of psychic skin, in sculptural form as well as two-dimensionally, Lin represents the vanguard of a nascent Chinese feminism.

Seeing Shadow No. 12 (2007; pl. 98), for example, is a large horizontal panel that depicts a gray photographic image of an abandoned Beijing *hutong* entangled in a web of broken trees and barren branches. Sewn onto the canvas are thousands of strands of silk, most of them balled up like bacteria growing in a petri dish. Other biological similes come to mind: cysts (some form of malignancy beneath the surface?), bundles of nerve endings, even antennae. Lin's sensibility as an artist turns inward when she works, resulting in a luminous skin that suppresses the photo-based image in favor of a handcrafted surface. The socially critical subject—soon-to-be demolished traditional architecture in a brutalized natural setting—gives way to a kind of psychic reclamation as the artist weaves her way across the face of the image, one silky strand at a time. As they cross, the strands conduct light, suggesting a web of residual energy from people, stories, and places no longer there—the half-lives of many dreams. "Great artists can paint mountains in the dark," Lin believes. "They do not have to see, only feel."[11] To become sensitive enough to capture the phantoms wandering across her silken surfaces, Lin, in a sense, has learned to turn her skin inside out.

Another layer of psychic skin in China is the written language itself. Though everyone in modern China learns to read and write as a child—a years-long act of rote submission to authority—the language of the public square does not belong to the public. Written language may appear in public—on posters, in newspapers, on billboards, and on the tightly controlled Chinese version of the internet—but it still follows the party line. Fracturing a character's radical to imply unstable meanings, inventing meaningless configurations of strokes, stamping words on flowing water, writing a traditional treatise in ink one thousand times on a piece of handmade paper until it becomes solid black, inventing new forms of

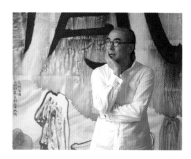

international written Chinese: these are some of the forms in which Chinese artists have challenged the central authority of the written language. Language that washes away, evaporates, darkens or negates one's face, breaks apart, or refuses to cohere not only offers the audience nonsense (and is thus dadaistic), but also shocks complacency into wakefulness. It allows the artists to speak in tongues—in a dream language that embodies a critique of the established social order while avoiding direct political attacks.

Gu Wenda was among the first Chinese artists to destabilize the written language, as early as 1984 enacting performances in which he painted dramatic, room-size ideographs on large, hanging banners of paper. Bringing to mind the posters of the Cultural Revolution, his controversial manipulations and reconfigurations of traditional characters, resulting in nonsense and quirky wordplay, confronted viewers with a graphic deconstruction of the language on a larger-than-life scale. His visual declarations said nothing directly but implied what could not be said: that the written language could be altered publicly—could be *spoken*—by acts of individual imagination. Rather than confining his pseudo-characters to the studio or gallery wall, Gu occupied literal and rhetorical space as an artist, surrounding himself with an elegiac, personal, and ceremonious form of speech. Needless to say, he found little support among the Chinese art establishment, and in 1987 he emigrated to the United States.

Gu is an avowed globalist, a sort of art diplomat who has displaced his youthful (and unfulfilled) faith in the state dream into an art-world version of a transnational, multiethnic unity. His family-of-man universalism is made manifest in human hair, now his principal artistic medium. Ubiquitous yet personally unique, hair is a kind of language encoding both the strains of a nation and the strands of an individual's DNA. Since 1993 Gu has been gathering hair from the floors of local barbershops the world over, weaving, gluing, and tying these shorn strands of protein into the pictographs, cursive, and arabesques of what appear to be written Chinese, English, Hindi, and Arabic (see pls. 94–95). In fact, however, Gu's hair writing is nonsense. The translucent sheets of metascript invoke not the dissonance of mistranslation or cacophonous ethnic verse, but rather a fantasy of speech as harmony: a polyphonous blending of voices or a kind of global singsong.

Yet it is not all that simple or uplifting. Gu's invented language, after all, is dead— it's hair. Its humanity lies not just its woven oneness, but also in its dismemberment—its having been cut from somebody's head. Spanning the lofty spaces of the international art arena, it cannot help evoking the ethnic and ideological slaughters of the last and probably every century. The glue that holds the hair in place glistens like a bodily fluid, and the

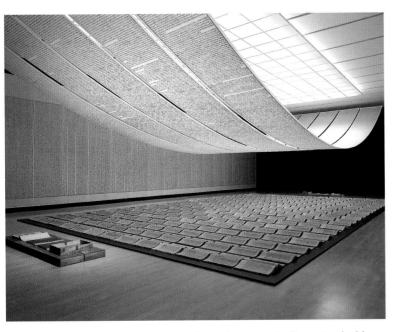

plate 17
XU BING (徐冰)
Book from the Sky, 1987–91
Hand-printed books
and scrolls
Dimensions variable
Courtesy Xu Bing Studio

hair itself—twisted, wadded, and squeezed into symbols that run broken across the wall—looks like the afterbirth of utopian rhetoric. A corporal weight, perhaps a tragedy, underlies Gu's optimistic language; as a child of the Cultural Revolution, he, too, was once shorn of speech. Speech now grows out of Gu like hair.

The art historian Norman Bryson once discussed artists' effacement of Chinese written script as a metaphor for a society in which the place of the individual was no longer determined by ideology. The ideological coherence of language as a unifying force across regions and time, so important to China's history, had given way, he believed, to a sense of its exhaustion—the semantic dimension had been emptied out of language, leaving ruined signifiers in its wake.[12] This helps explain the cynical reasoning of the Chinese avant-garde of the 1990s. The unification of meaning was revealed to have been a form of collective half-consciousness, and the breaking of language—of its officially imposed coherence—was a way for artists to rouse themselves from the state dream.

If the nullification of meaning in language opened the way for cynical reasoning—whereby the skeptic knows his beliefs are empty but is enlightened about his complicity in the dominant order (and, because he has no faith, is thereby immune from the charge of bad faith)—it also opened the door to what the artist Xu Bing has called "in-between" experiences: that is, experiences in the cracks between language(s), when words (or characters) are present but meaning is absent. Therein we are open to something in between what we expect and what we experience—the hypnagogic state between sense and nonsense.

Xu became famous for inventing a language that looked Chinese but could not be read. Working in relative isolation in his small, cell-like studio at the Central Academy of Fine Arts in Beijing, he painstakingly carved four thousand made-up characters into wooden printing blocks, which he used to print his seminal *Book from the Sky* (1987–91; pl. 17). Comprising long scrolls sweeping down from the ceiling and an array of hand-bound books, with additional scrolls hung on the surrounding walls (a traditional means of expressing

dissent in China), ***Book from the Sky*** offered itself as Chinese but was really indecipherable. First exhibited in Beijing in 1988, it was hailed as signaling a new direction in experimental Chinese art.

Trained in Socialist Realism, Xu felt the relationship between style, form, and meaning was too obvious in that artistic genre. Like most Chinese artists of his generation, he was not sure how to visually convey what he was thinking; rather than turning toward his own image, as so many Chinese artists did, he focused on writing. In effect, he wrote his confusion—what he did not understand—in a language that he could not read. In Chinese tradition, things that cannot be understood are called books from the sky. The classical word for *book* is also the character for *mirror,* so the title ***Book from the Sky*** can also be understood to mean "a mirror for the examination of the world." As in any mirror, the world is reflected backward.

This was not a cynical gesture, but an enactment of monkish detachment, like daily prayers. By carving his invented and meaningless characters, Xu invited paradox: speaking on a public scale with private utterances, practicing precision in the service of ambiguity, learning a language that could not be spoken, undertaking scholarship in reverse, starting with the knowledge of a language and ending with the experience of no language. Thus, by carving his meaningless alphabet, Xu made a positive imprint of his confusion as an artist. Unlike Gu's broken or inverted script, Xu's text is fully meaningless, beginning from nothing. At the same moment, it is beautiful: precisely carved and carefully printed, each character is a refined whole, minus only its semantic dimension. The subtraction of semiotic familiarity makes written Chinese as purely visual (and meaningless) for those who can read the language as it is for those who cannot.

For many, ***Book from the Sky*** represented the futility of expression in China, where official language permeated the atmosphere of the state dream. Although Xu's project preceded Tiananmen Square, after 1989 this interpretation made a certain amount of sense. Indeed, the absurdity of devoting so much time to inventing a meaningless language may be seen as a metaphor of the imprisonment of speech in a society where, throughout history, intellectuals learned to speak in riddles and resorted to codes read backward in mirrors. Chinese children must devote years of rote study to master the ten thousand characters necessary to read a newspaper, but when they become old enough to have something to say they dare not speak directly. Thus, Xu's act of carving his language paralleled the process of learning Chinese as a child.

In 2007 Xu made a series of hanging birdcages whose metal screening is fashioned from English letters. Inside each cage is a brightly colored mechanical bird that responds to noise by singing. The text that wraps around the cages recounts questions Xu has been asked about his art as well as his responses to such questions. One cage (pl. 32) represents an exchange between the artist and Jacques Derrida, the Algerian-born French philosopher who founded the critical method known as deconstruction, a way of understanding the shifting meanings and customary hierarchies of language through the scrupulous analysis of texts. The birdcage reads in part: "Xu Bing and Derrida 'installed' in the same space I remember saying to Derrida 'Although so many people have used your theories to interpret *Book from the Sky* I had never read any. . . .'" If one recites the text out loud the mechanical bird interrupts, its singing humorously deconstructing the sound of the words. Because it "interrupts" the readings and meanings of extant texts, Derrida's theory of deconstruction, so influential in the postmodern conception of knowledge and experience, is often referred to as a philosophy that, in itself, says nothing. Language, Xu's work implies, is a cage. The dream of the bird is to escape.

Twenty years on, Xu's interruption of language in *Book from the Sky* hangs in the mind as a moment in which the Chinese sky collapsed—and with it the sense of official meaning that kept the state dream aloft. In its time significant art can stand for a future that has not yet come into play. The philosopher Jean-François Lyotard referred to this as the "future anterior," or the idea that artists, among others, invent games for which rules have not yet been invented. Today the ways in which the Chinese speak, hear, and think about themselves have been utterly transformed by exposure to the global matrix of economic and cultural exchange and to the networks of the digital age. The magnitude of this change was unimaginable to most of us when artists in China began making contemporary art. It is curious to recall that during the Tiananmen Square uprising fax machines were the principal means of sending and receiving information between Chinese dissidents and the West. Within five years Chinese entrepreneurs were walking around with cell phones the size of walkie-talkies, and China's vanguard artists, whether by expatriation or ambition (or both), were infiltrating the networks of the international avant-garde.

Each morning in the parks of Beijing older men arrive carrying songbirds in hooded cages, waiting for the right moment to uncover the birds and expose them to the light of a new day so they might outsing one another. One has the sense that in generations past the birds would have been eagles or hawks—birds of prey—and the men Manchu

warriors. Today bringing songbirds to parks is a leisure pursuit, but when the cages are uncovered the vestiges of some ancient competition are revealed. In 1958 the Communist Party decided that there were too many sparrows in China competing with the people for grain. "Kill the sparrows to save your crops," Mao said. Millions of peasants and city dwellers destroyed nests, killed nestlings, and banged pots and pans in order to frighten the sparrows and keep them aloft. Because sparrows can remain in continuous flight for only a short time before dying of exhaustion, an estimated four million birds perished in Mao's campaign to rid the land of the counterrevolutionary sparrow. Most literally fell from the sky. The ecological consequences, of course, were disastrous: it turned out that sparrows had been the people's allies all along, eating mostly insects. Mao's countermanding order to stop the killing was simple: "Forget it." With the politically rehabilitated sparrows gone, however, insects ate the grain and famine set in. The state dream became a nightmare in which sparrows fell from the sky.

The Chinese no longer see themselves as subjects suspended in a state dream, but rather, perhaps, as a billion-plus sparrows hurtling toward a horizon that may represent an awakening. The hood has come off the cage, but the light of day does not just reveal the morning—it radiates the blinding, noxious half-life of an ideology that could only have been realized in the context of an imposed hallucination. *Blind Talker* (2005; pls. 33–46), a single-channel video projection by Wang Gongxin, one of China's pioneers in new media, captures this sense of the Chinese people as caught in a dream and blinded by the light. A studio production set in the clouds, the twelve-minute video shows an aging senior, a middle-aged adult, and a prepubescent boy—all blind—making their way slowly through a bright, billowy atmosphere by means of sound and touch. A honey-colored birdcage hangs in the space, and the old man taps it with his cane. Because the sound—like the motion—is slowed down, the tap of the old man's cane deepens into a thwunk that resonates like sound underwater. The voices of him and the boy also fall and lengthen. The birds, however, are recorded in real time; their chirping and singing lifts the spirit and guides the way—aural cues in an isotropic environment. Other things happen: people ride bikes through the fog like fleeting apparitions, the music of a stringed instrument plays backward, a bird sits quietly on a man's fingertip, and the middle-aged man on a khaki motorized bike drives the boy, who wears sunglasses and angel's wings, up into the blue sky like Icarus toward the sun. Uplifting music lofts them. They smile and rock their heads as they ascend. Though they cannot see, they are going somewhere, somehow, like sparrows chased from a tree.

There is a sense today among Chinese artists that most people don't have time to dream because China is moving too fast. To speak of a nation moving too fast is probably to speak of one's impression of change in the local environment—in Beijing, for instance, with its chaotic traffic, growing skyline, influx of foreigners, easy money, and so forth. Change is hard to gauge from inside. One's perspective is entangled with shifting lanes of memory, with familiar places that no longer exist, with soaring corporate edifices built nearly overnight and boulevards of national destiny blanketed with taxis moving too slowly. Displacement and disappearance are the constants. One navigates through an uncertain, half-remembered territory in which the old points of reference are like ghosts fading away in the light of China's new day. The state dream may be over, but the dream state persists.

If the ideological dreamscape of China is no longer collective, neither is there a tradition of individual dreaming in the American sense. Paradoxically, the dreams of individuals remain embedded in collectivist slogans such as "Everybody get rich!" In this sense the Chinese are not yet capitalists, most mistaking capitalism for being rich. Their collective dreamscape, however, has become the stock market. In October 2007 the Seventeenth Party Congress declared that citizens should increase their income via investments. For the first time the Chinese were officially encouraged to make money from money, not labor. This is a profound psychic turning point. The art-world version of the stock market is the auction market, of course, and many Chinese artists—especially the younger ones—have come to see it as their principal audience. Artists studying in China's academies today were born during the New Wave movement, and they have grown up knowing their teachers as (increasingly) famous and affluent. This generation's dream of China will not be ideological, but rather cultural. Indeed, the international art world (art fairs, biennials, and auction houses) is now their dreamscape: a kind of stateless realm of mingling aesthetic currencies, benign statesmanship, and jet lag–induced euphoria. Like everyone else in China, young artists dream of being rich (the utopian impulse has been privatized). And yet, Chinese artists born in the 1970s look back upon the ruins of socialist utopianism with a guarded nostalgia for the sense of collective purpose and social stability they recall vaguely from their own—or from other peoples'—childhoods. They do not idealize that time, but they do remain fascinated, as artists, by its hollow slogans, empty spaces, and faded patinas—the psychological remnants of Mao's stages, stadiums, and public squares. The nostalgia younger artists feel today for the collectivity of the past, though ironic, is not cynical. It may be a longing for something other than mere success. In part because they do not remember failure, the era of cynicism in Chinese art is over.

When asked in the late 1990s why a Chinese avant-garde had emerged in the first place, Wang Gongxin answered in imperfect but perfectly clear English: "To against the official art."[13] When asked in 2007 whether the era of collective dreaming in China was over, he called attention to the official slogan of the Beijing Olympics: "One World One Dream."[14] It is not over.

Chinese artists know that the dreamed self is not the same as the conscious self. Works of art are representations of the dreamed self, but they are not the artists' actual dreams. In China those are dreamed, as it were, through Zhuangzi's butterfly: a third party, the subconscious, maybe art, but something the artist cannot control. Ultimately, it is the consciousness of consciousness that is at stake, without which there is no art, only recurring apparitions from a half-remembered past. One of the reasons Chinese artists are so important today is that they remain tied to the fate of their nation (not every nation's artists can make that claim). The faces they paint, the masks they wear, the ghosts they glimpse, the heroes they remember, the vases they break, the spaces they haunt, the skins they expose, the fingers they sever, the writing they nullify, and the birds they cage are not merely market calculations designed to give the West what it wants. Chinese art is more profound than the market. It represents variations on the effort of a nation to awaken, over and over, from the paralysis of the state dream. It represents the half-life of that dream.

Notes

1 The explosion of consumerism in China during the 1990s may be interpreted as a psychic compensation for the loss of hope in political reform.

2 C. W. Chan, "The Butterfly Dream," *The Philosopher* 83, no. 2, http://www.the-philosopher.co.uk/butter.htm (accessed March 21, 2008).

3 When asked if the studio is a refuge from the business world, Zhang Xiaogang answers: "No. In the 1980s the studio was a private place, mostly because nobody went there. Today people bang down the door to get in. It's like a workshop. Making art is supposed to be private, even lonely. But if you close the door, nobody will care about you anymore." These and other quotes by Zhang are from a conversation with the author, October 31, 2007.

4 Or is the painting an artist's commentary on narcissism, the painter now doubled in order to admire himself?

5 Sheng Qi was initially a member of Concept 21, a group of Beijing artists whose December 1986 performance on the campus of Peking University helped rouse students against ideological repression and the lack of academic freedom. Drawing upon the choreography of political street theater during the Cultural Revolution, Sheng and several art-school cohorts wrapped themselves in billowing fabric, rode bicycles through a crowd of gathering students, and painted themselves yellow, red, and black before climbing to the roof of the student dining hall, where they faced the cheering crowd and poured ink on themselves. Later that day, students at the university publicly demonstrated in favor of greater openness in China, beginning a period of antigovernment protests and backroom party maneuvering that culminated in the tragic events of June 4, 1989.

6 Mary Jane Jacob, "In the Space of Art: Zhang Huan," in *Buddha Mind in Contemporary Art*, ed. Jacquelynn Baas and Mary Jane Jacob (Berkeley: University of California Press, 2004), 247.

7 Ai Weiwei, interview by Britta Erickson, July 14, 2006. Excerpts published in auction catalogue for *Contemporary Art Asia: China Korea Japan* (New York: Sotheby's, 2006), 137.

8 Reuters, "Chinese Architect Slams Olympic 'Pretend Smile,'" *CNN.com*, August 13, 2007, http://edition.cnn.com/2007/WORLD/asiapcf/08/13/china.olympics.reut (accessed March 19, 2008).

9 Unless otherwise noted, these and other quotes by Ai Weiwei are from a conversation with the author, October 9, 2006.

10 Liu Hung, unpublished artist's statement, 1995.

11 Lin Tianmiao, conversation with the author, October 31, 2007.

12 See Norman Bryson, "The Post-Ideological Avant-Garde," in *Inside Out: New Chinese Art*, ed. Gao Minglu (San Francisco: San Francisco Museum of Modern Art; New York: Asia Society Galleries; Berkeley: University of California Press, 1998).

13 Wang Gongxin, conversation with the author, August 16, 1999.

14 Wang, conversation with the author, March 30, 2007.

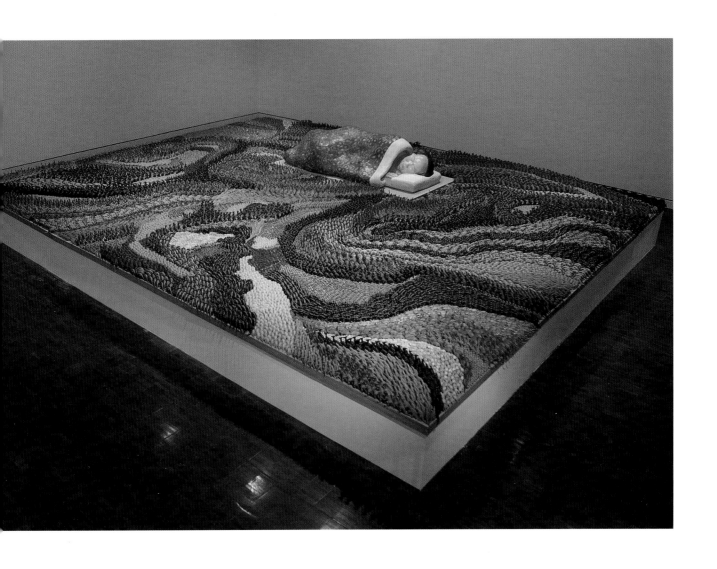

plates 18–20 SUI JIANGUO (随建国) *The Sleep of Reason,* 2005 Automobile paint on fiberglass and resin, plastic, and wood
Dimensions variable

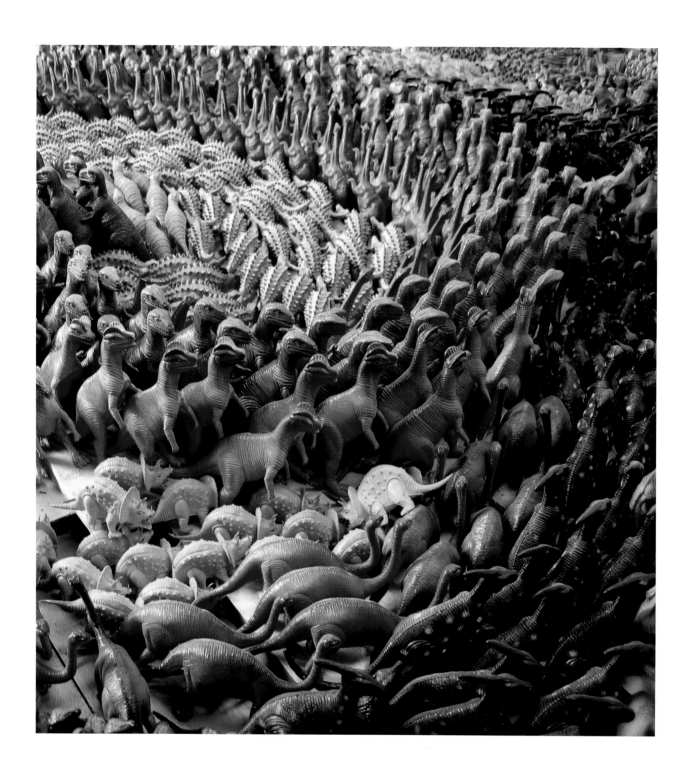

plate 21 SUI JIANGUO 〔随建国〕 *The Sleep of Reason,* 2005 Automobile paint on fiberglass and resin, plastic, and wood Dimensions variable

plate 22 SUI JIANGUO [随建国] *Made in China*, 2005 Automobile paint on fiberglass 78 ¾ × 40 × 72 ⅞ in.

plate 23 SUI JIANGUO (随建国) *Legacy Mantle,* 2005 Automobile paint on fiberglass One of five pieces, each: 24 ½ × 19 × 14 in.

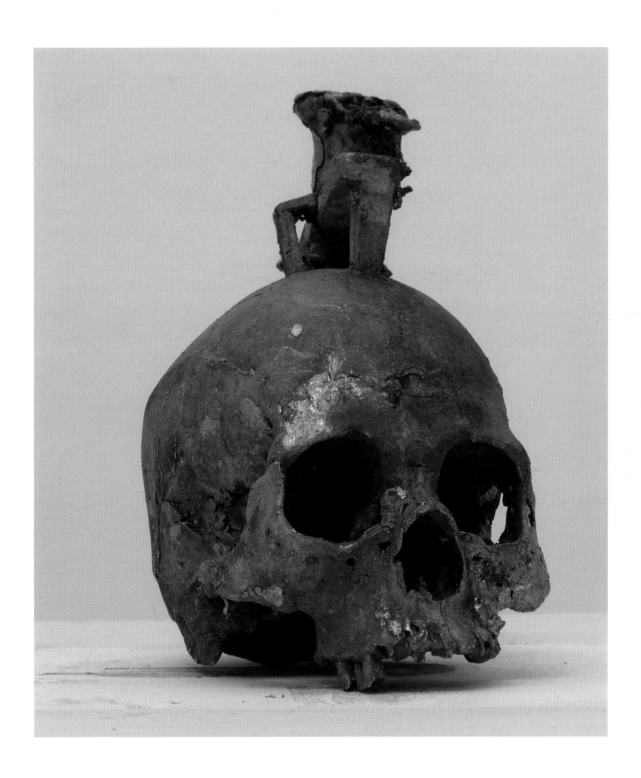

43 plate 24 SUI JIANGUO (随建国) *Impermanence*, 2006 Lead 10 ¼ × 6 ¼ × 7 ⅞ in.

plate 25 ZHANG XIAOGANG (张晓刚) *Untitled,* 2005–6 Oil on canvas 98 ⅜ × 118 ⅛ in.

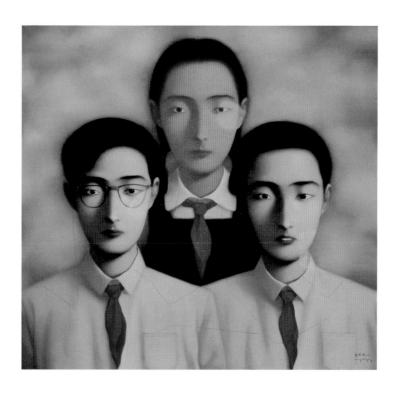

plate 26 ZHANG XIAOGANG 〔张晓刚〕 *Big Family,* 1996 Oil on linen 57 × 61 in.

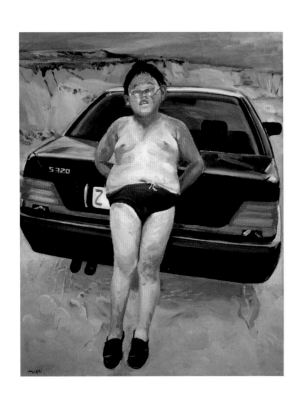

plate 27 LIU XIAODONG (刘小东) *Fat Grandson,* 1996 Oil on canvas 90 ½ × 71 in.

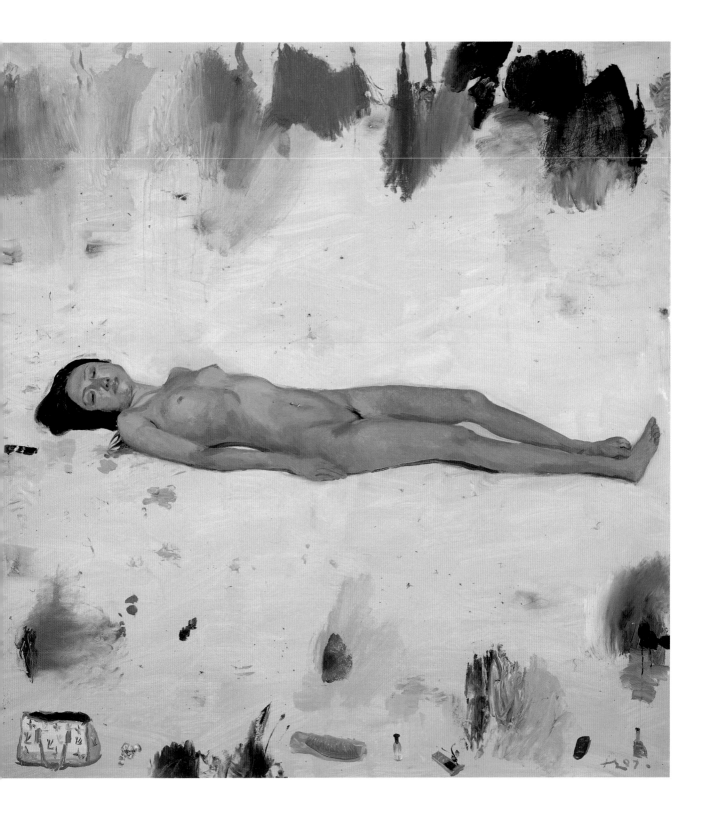

plate 28 LIU XIAODONG [刘小东] *Xiaomei*, 2007 Oil on canvas 78 ¾ × 78 ¾ in.

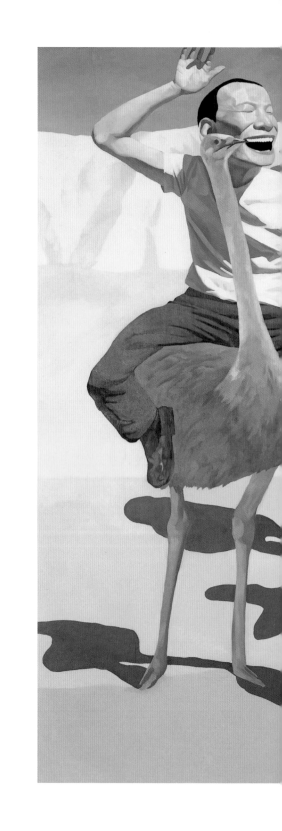

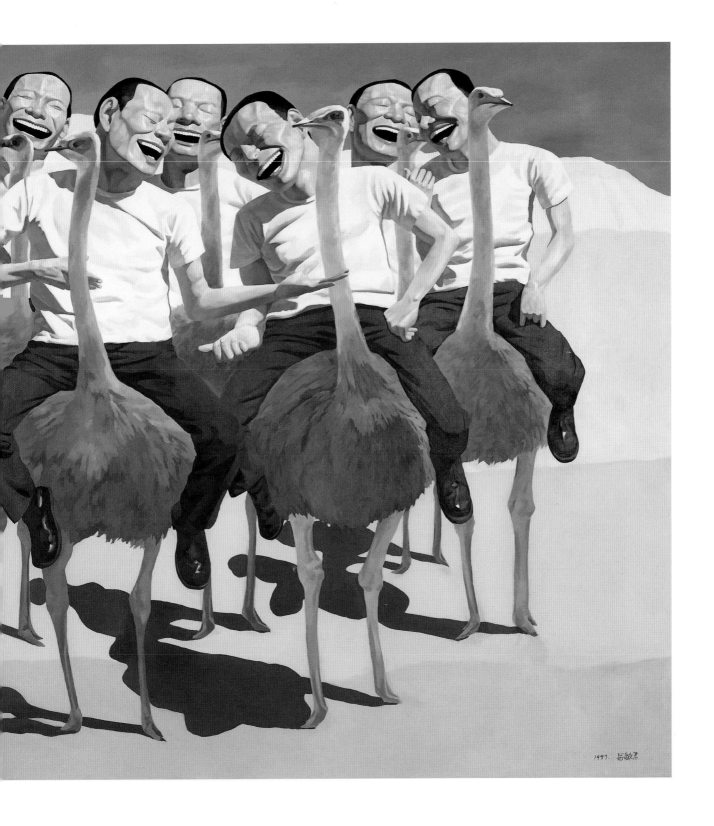

plate 29 YUE MINJUN 〔岳敏君〕 *Ostriches*, 1998 Oil on canvas 78 ¾ × 110 ¼ in.

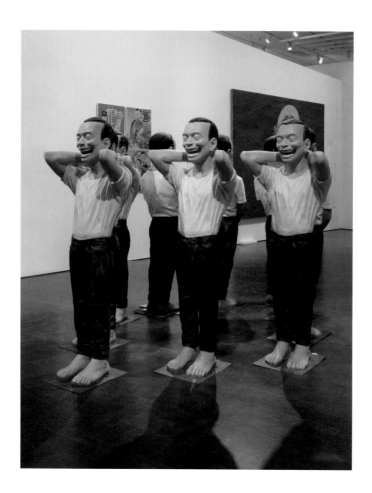

plate 30 YUE MINJUN 〔岳敏君〕 *The Last 5000 Years*, 2000 Acrylic on fiberglass-reinforced plastic
Five figures, each: 72 ½ × 29 × 23 in.

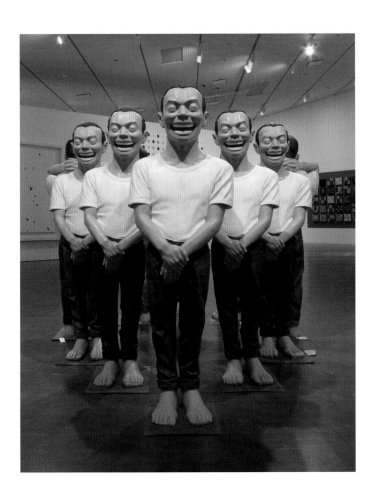

plate 31 YUE MINJUN〔岳敏君〕 *Contemporary Terracotta Warriors,* 2002 Acrylic on fiberglass-reinforced plastic
Five figures, each: 72 × 23 × 21 in.

51

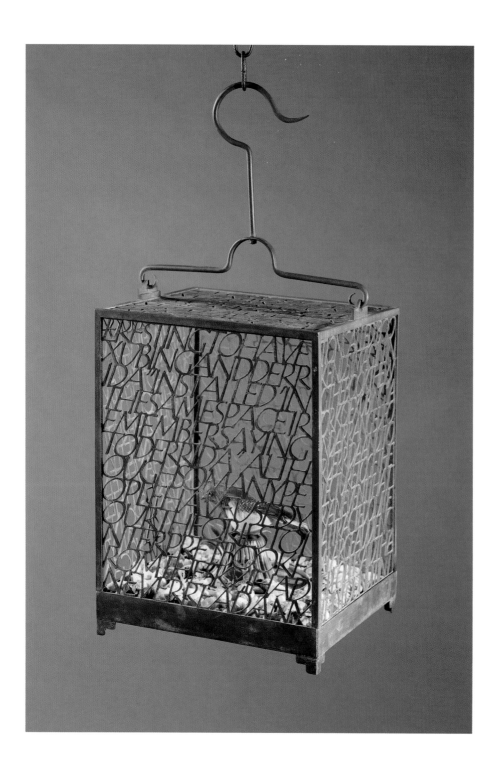

plate 32 XU BING 〔徐冰〕 *Bird Language*, 2004 Copper, mechanical plastic bird with feathers and audio sensor, and gravel 21 × 9 × 9 in.

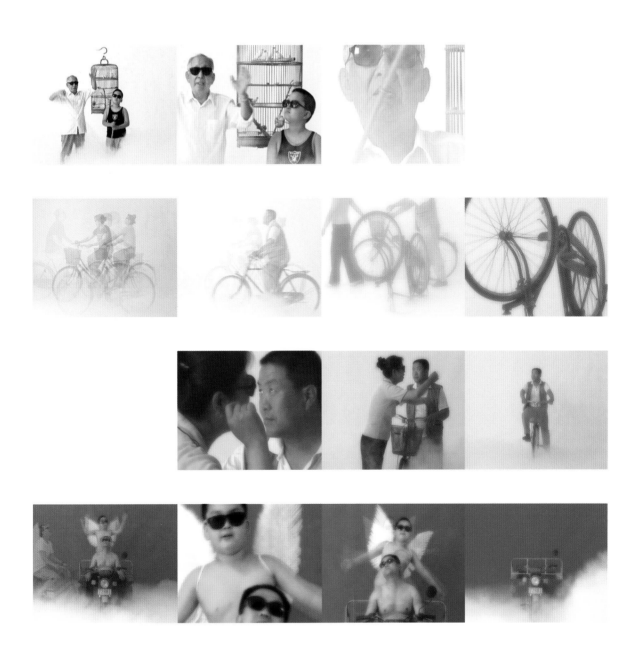

plates 33–46 WANG GONGXIN 〔王功新〕 *Blind Talker,* 2005 Single-channel video projection, 12 min.

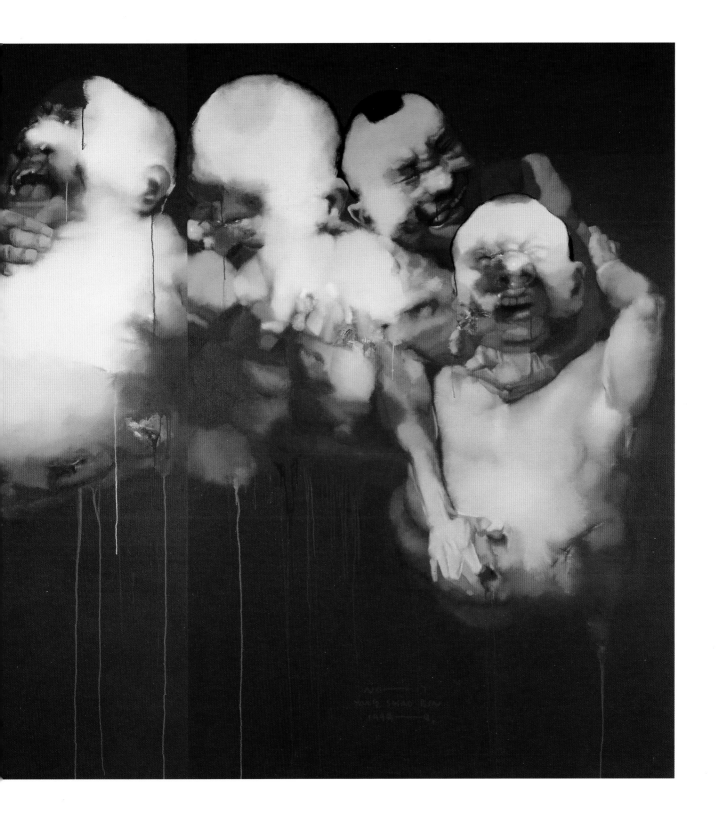

plate 47 YANG SHAOBIN [杨少斌] *Untitled (1999–4),* 1999 Oil on linen Two panels, overall: 90 ½ × 141 ¾ in.

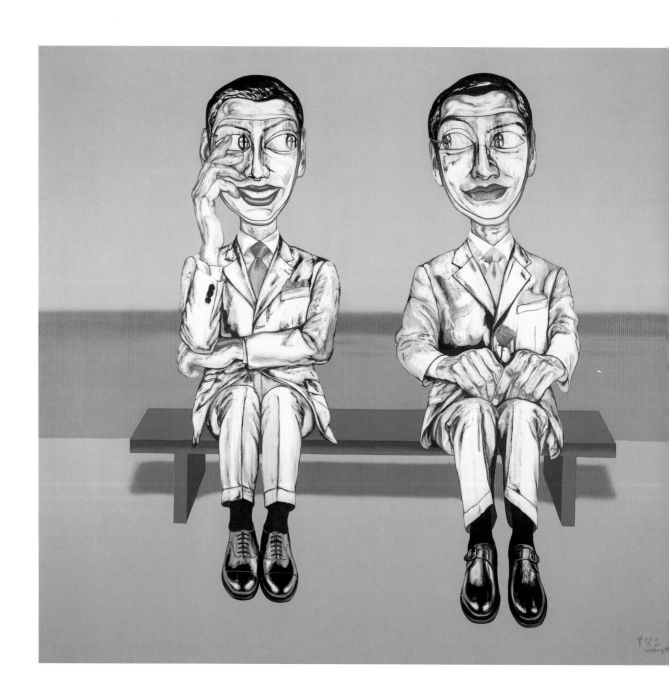

plate 48 ZENG FANZHI (曾梵志) *Mask Series No. 10*, 1998 Oil on canvas 70 ¾ × 78 ¾ in.

plate 49 ZENG FANZHI (曾梵志) *Meat,* 1992 Oil on canvas 71 × 59 ¼ in.

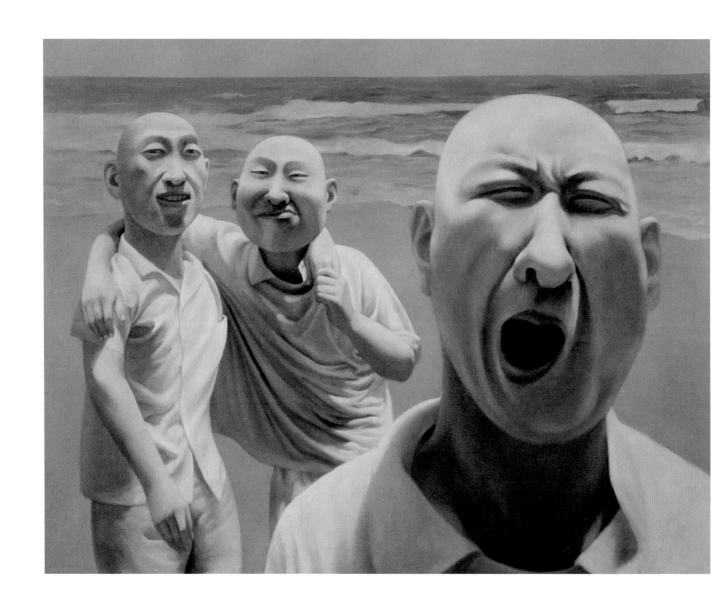

plate 50 FANG LIJUN [方力钧] *Series 1, No. 3*, 1990–91 Oil on canvas 31 ⅝ × 39 ⅛ in.

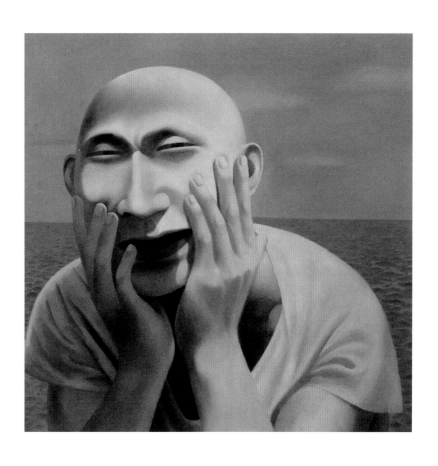

plate 51 FANG LIJUN (方力钧) *Series 1, No. 6,* 1990–91 Oil on linen 39 × 39⅛ in.

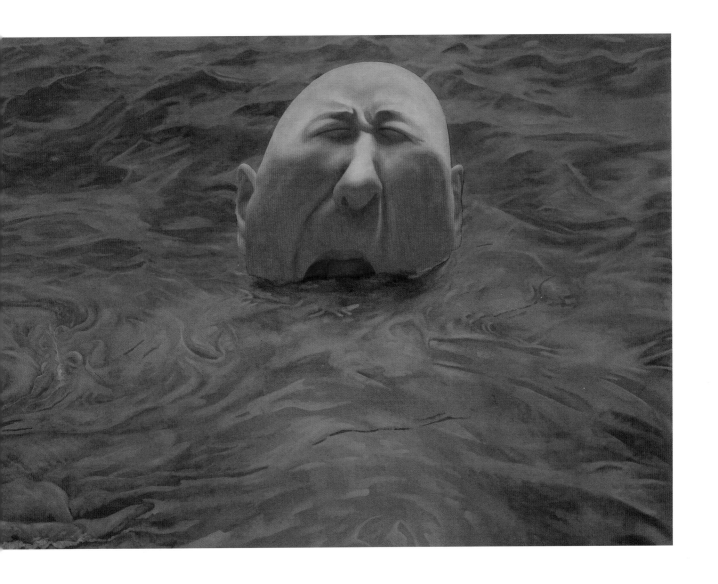

61 plate 52 FANG LIJUN [方力钧] *980815*, 1998 Oil on canvas 98 ⅜ × 141 ¾ in.

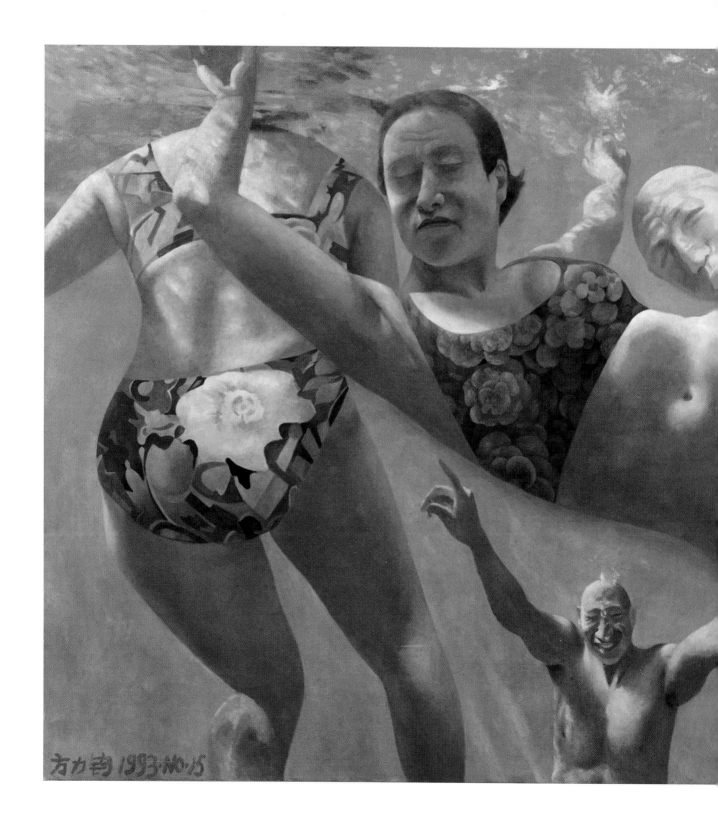

plate 53 FANG LIJUN [方力钧] *Series 3, No. 15,* 1993 Oil on canvas 71 × 102 in.

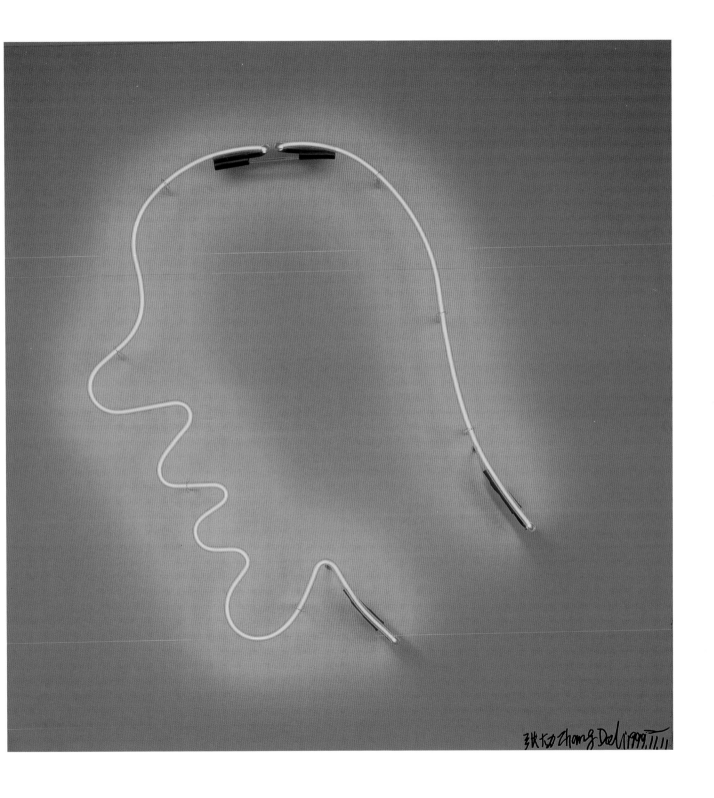

plate 54 ZHANG DALI (张大力) *Dialogue 11/11/99*, 1999 Neon on canvas 48 × 48 × 5 in.

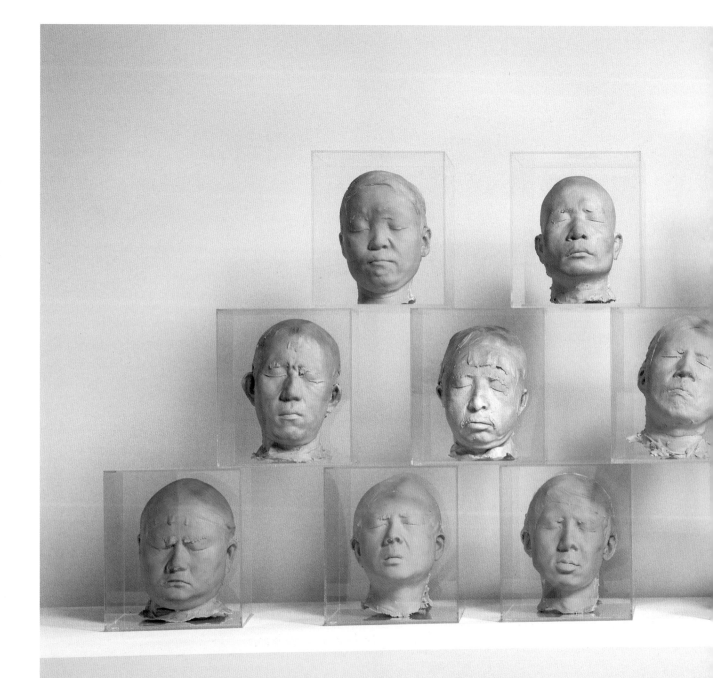

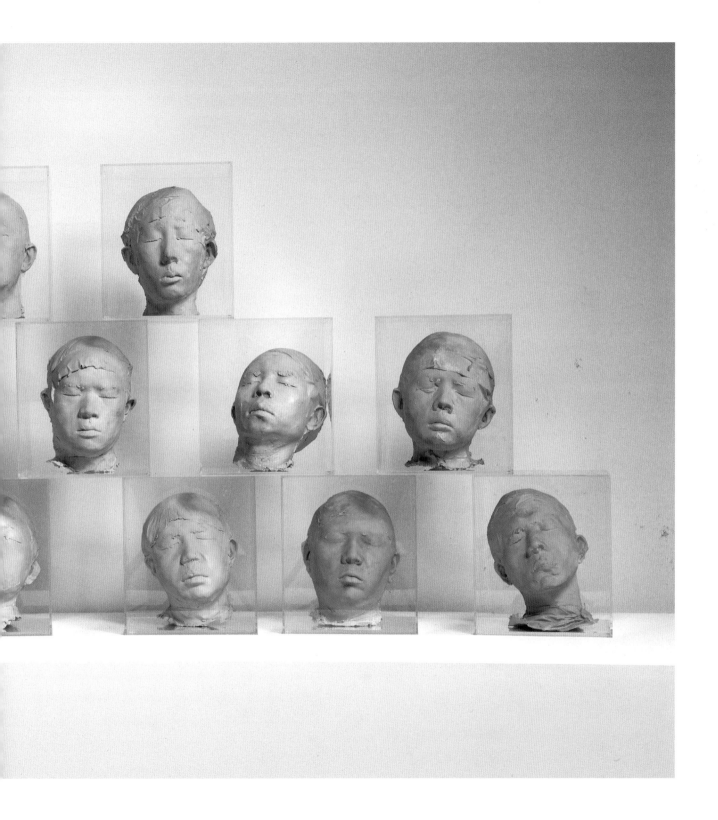

plate 55 ZHANG DALI 〔张大力〕 *100 Chinese,* 2001 Synthetic resin Seventeen pieces, each: 11 ¾ × 9 ⅞ × 9 ⅞ in.

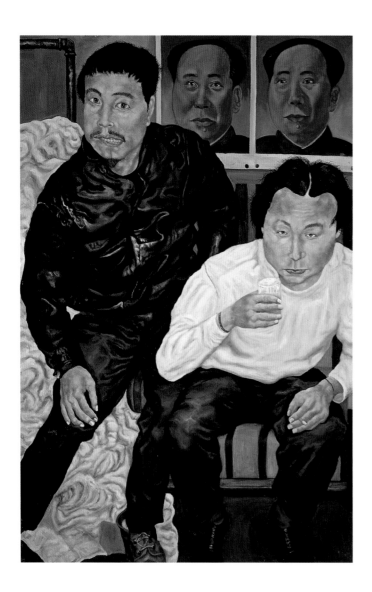

plate 56 LIU WEI (刘炜) *Two Drunk Painters*, 1990 Oil on canvas 59 × 39 ½ in.

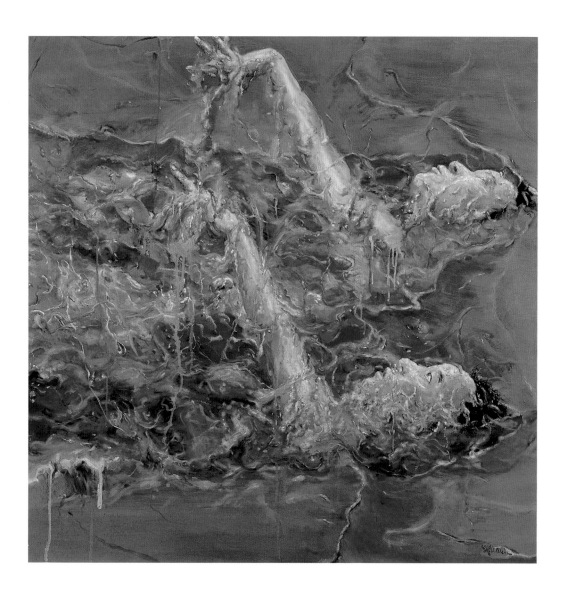

plate 57 LIU WEI (刘炜) *Swimmers,* 1997 Oil on canvas 40 ½ × 40 ½ in.

plate 58 YIN ZHAOYANG (尹朝阳) *Untitled,* 2005 Oil on canvas 79 × 118 in.

The Potency of the Mask:
Ancient Rites in Contemporary Chinese Art

Christoph Heinrich

"China's Slipping Happy Mask" is just one of many headlines in recent years to invoke the mask as a metaphor in reference to China's economy and politics.[1] Beneath this trope one senses the uncertainty and discomfort of the West in the face of the booming economy of the world's most populous country. And yet, though double-digit growth rates may cause concern and suggest a ruthless business environment, in negotiations with the Chinese one encounters only unflappable friendliness. • Such "happy masks" can also be found in the works of a number of contemporary Chinese artists who, in recent years, have engaged their audiences with masklike portraits and props, generally distinguished by a certain facial type, its features frozen into a stiff disguise. From the perspective of the art market this might be considered a calculated bid for commercial success. After all, we are regularly reminded that human beings are genetically programmed to fixate on the countenances of fellow members of the species, subconsciously recognizing faces in a split second and relying on them for cues.

ZHANG XIAOGANG [张晓刚]
Big Family, 1996
detail of pl. 26

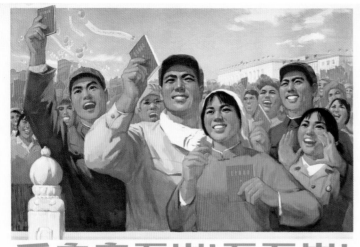

plate 59
SHANGHAI FINE ARTS ACADEMY
WORK PROPAGANDA TEAM,
REVOLUTIONARY COMMITTEE
Long Live Chairman Mao!, 1970
Offset lithography
21 × 30 in.
Stefan R. Landsberger Collection,
International Institute of Social History,
Amsterdam

But business and marketing concerns aside, it is worth considering what meanings might be associated with artistic use of stereotypical facial expressions. Are the masks' distorted features meant only as camouflage, concealing intention and emotion? Or is this reading limited by our own traditions in the West, where masking is often identified with deceit and disguise? And is not that view itself too narrow, even within the Western context, neglecting more significant meanings that may have become buried over time?

Smiling in Service of the Revolution

The disquieting grin has become something of a formula in contemporary Chinese art. And yet in China, wide mouths and bared teeth are an invention of the second half of the twentieth century. One rarely comes across a smiling figure in traditional Chinese painting; instead expression is conveyed through small, stylized mouths, rendered in graceful dashes and arcs consistent with the Confucian ideal of central harmony. Not passion and exuberance but equanimity and inner equilibrium were the way to the golden mean. Smiles only became permissible during the Cultural Revolution, with its patriotic depictions of proudly toiling laborers and enthusiastic field hands. Their masklike display of happiness is especially striking in the propaganda posters of the time: brawny men and freshly coiffed women, neatly dressed and beaming, go about their work and play with unfailing good cheer, the broad smiles on their faces speaking volumes (see pl. 59). Ubiquitous from the 1950s to the 1980s, these posters were the matrix that shaped the visual awareness of artists who

are now aged forty to sixty. During the liberal 1990s, the stereotypical image of the smiling comrade came under critical scrutiny and made its appearance on the international stage of contemporary art.

In the works of artists associated with Political Pop, the enthusiasm expressed through face and gesture was redirected toward the achievements of Western consumer culture. They celebrated not the values of Communism but the rewards of the free market with revolutionary emphasis, and the discrepancy between the "high" of emotion and the "low" of mass production yielded the tension that pushes the paintings of artists such as Geng Jianyi, Wang Guangyi (pl. 109), and Yu Youhan (pl. 102) into the realm of the grotesque.

The frozen laugh of the mask as an expression of frustration and scorn for both past and present is part of the language of Cynical Realism, a term coined in the 1990s by Li Xianting, the dean of a new wave of Chinese art criticism.[2] He applied the term to a group of young artists whose figural paintings represented a generation of urban youth—those who responded with aggressive indifference and derision to the political aftermath of the Tiananmen Square massacre and China's rapid modernization.

Masks and Magic

A question that has not yet been considered is whether the use of the mask might not also represent a reappropriation of past traditions. Could not the deployment of the stereotypical face, whether smiling or earnest, also have atavistic and magical implications?

Masks conceal but do not neutralize the wearer. In both Western and Asian traditions, they provide added content, clothing the wearer in spiritual, historical, erotic, and military connotations. Evidence of masking goes as far back as the Paleolithic era, with its cave paintings of individuals, presumably shamans, wearing animal masks. In all world cultures, masks are associated with ritual activities, most of which have become lost with time or transformed and secularized. Their origins, however, lie in magic. The mask, in its most ancient sense, is a tool for communicating with the gods and spirits.[3]

While the stiff smile may be relatively new to Chinese art, the wide grin is commonplace in ritual masks of all performance traditions in Buddhist and Asian folk culture, which have used the stylized expression for centuries to invoke gods and demons. Throughout Asia masks are primarily implements of temple worship and of theatrical practices that have evolved out of ritual. Most familiar in the West is the grimacing lion costume paraded in Chinese New Year celebrations: color, pattern, ornament, and decoration amplify the gestures

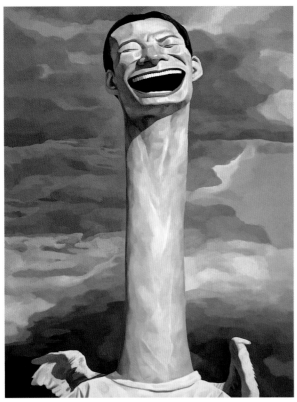

and movements of the performers, their disguise symbolizing the inevitable exorcism of evil spirits and the fulfillment of all good wishes. But this is just one of many masks related to worship and battle, as well as to the resurgent Nuo theater, that make up the vast storehouse of Chinese mask types.[4]

Yue Minjun: The Artist as Shaman

Magical rites, popular for thousands of years in China, were practiced across wide parts of the country by a diversity of ethnic groups. Over the centuries these rituals evolved into distinct forms, yielding a great variety of masks and dances.

During the years of the Cultural Revolution, however, the government banned such customs, suppressing them as reactionary superstitions and holdovers from feudalism. Under the cover of anonymity, aspiring to godlike or demonic powers, the masker placed himself above authority. Under the light of Mao, "the red sun in our hearts," such effrontery was as unwelcome as any belief in gods and demons; only very few authentic masks survived this period.

Since the 1980s there has been a resurgence of interest in these ancient rites.[5] If we consider the artist in modern society not merely as an entrepreneur producing visual entertainment (and, if successful, economic value), but also in a broader context that assumes an anthropological constant, then the artist could long ago have taken on the role of shaman.[6] The artist performs rituals, enters into contact with the past, and communicates with a world that eludes the rules of rational thought. In an effort of collective exorcism, the artist's magical powers are the ambiguity of poetry and the unerring aim of intuition.

These are the premises under which we approach Yue Minjun's "silly man," the perpetually grinning, endlessly reproducible self-portrait of the artist. Mouth open wide, eyes tightly shut, he occasionally appears as a single figure (*Swan*, pl. 60) but more often in a group (*The Last 5000 Years*, pl. 30). Multiplied, he becomes the quintessence of "the superannuated principles of collectivism and egalitarianism."[7]

But Yue also uses the silly man to reinstate the figure of the anarchic clown, a stock character in the masking traditions of all cultures. In Chinese Nuo theater, which dates back

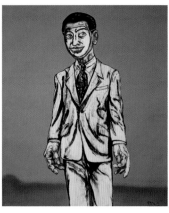

plate 62
ZENG FANZHI (曾梵志)
Mask Series No. 9, 1994
Oil on canvas
59¼ × 51¼ in.
Collection of Vicki and Kent Logan, fractional
and promised gift to the San Francisco
Museum of Modern Art

plate 61
Nuo Theater Mask: Qin Tong,
twelfth century
Wood
10 × 5½ × 2 in.
Private collection

to the fifth century BCE, this role is assigned to the servant Qin Tong (see pl. 61). His face twisted in a characteristic smirk, he is agile and mischievous, as bold as he is unscrupulous— and would surely, given the opportunity, try to ride a flightless bird (*Ostriches,* pl. 29). Qin Tong is a key figure in Nuo because his ability to laugh and elicit laughter was considered one of the most potent weapons of exorcism; laughter, the Chinese believed, could drive away demons. He is the buffoon whose pranks delight the audience: the abused servant, kin to Arlecchino, one of the numerous *zanni* of Italian commedia dell'arte, whose counterparts can be found in many of the varied forms of shamanism.[8]

At first reading a caricature of the artist as a cloned comrade soldier, the silly man is also a stand-in shaman figure. His grins and grimaces are weapons; his rows of white teeth suggest readiness for battle. Inner life and personality are barricaded behind eyes squeezed shut as though in a trance, while the bared teeth hold evil spirits at bay.

Nuo is a rite of exorcism, a purging of the evil spirits of the past that unites all members of a tribe or group. In a materialistic present less inclined toward belief in the demonic powers of chthonic forces, these are replaced by collective psychoses, by the force of memory, anger, and shame. Yue's silly-man mask is not merely a covering that conceals identity and personal feelings, but also an instrument of modern exorcism. If the idol as a magnification of the self is intended to protect the individual, the multiplication of the self owes something to American Pop art and its celebration of mass production.[9] Yue's game of masks could be seen as a synthesis of Andy Warhol's belief in the benefits of infinite repro- ducibility (Warhol titled his 1963 version of the Mona Lisa *Thirty Are Better Than One*) and forms of ritual rooted in the artist's own tradition.

With his standing synthetic-resin figures (*Contemporary Terracotta Warriors* [pl. 31], for example), he marches out an army of laughing men, reinterpreting the quiet dignity of the famous Qin Dynasty terra-cotta warriors through the strident, aggressively bellicose tones of a modern exorcism.

Zeng Fanzhi: Banishing the Past

Surely no Chinese artist is more identified with the use of masks than Zeng Fanzhi. In his *Mask Series* (1994–2000) he outfits all figures with a pale, close-fitting mask. The prop transforms his subjects, often dressed in elegant Western clothes, into anonymous clones incapable of self-determination. The masks signify a uniformity one might have thought was overcome through contact with the West. In pictures such as *Mask Series No. 9* (pl. 62) and

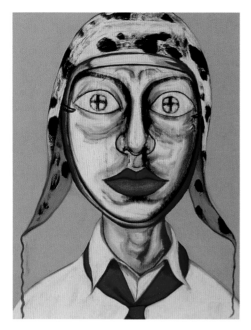

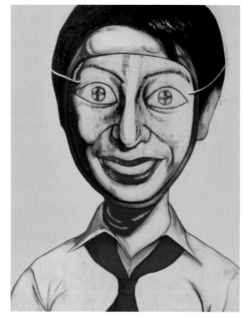

plate 64
ZENG FANZHI (曾梵志)
Class One Series No. 27, 1996
Oil on canvas
19 × 15 in.
Courtesy Schoeni Art Gallery, Hong Kong

plate 63
ZENG FANZHI (曾梵志)
Class One Series No. 19, 1996
Oil on canvas
19 × 15 in.
Courtesy Schoeni Art Gallery, Hong Kong

No. 10 (pl. 48), the stereotypical faces seem to turn an inner emptiness inside out.

Zeng's ***Class One Series*** (1996; pls. 63–64) sheds light on the origins of this prop. In thirty-two individual portraits, all wearing identical masks and the red neck scarf of the Young Pioneers, the artist "portrayed" the class of the "little red soldier Zhi Zhi," who in the summer of 1970, at the height of the Cultural Revolution, kept close watch on the father of a fellow student, a disseminator of counterrevolutionary ideas, "until the bad person was finally arrested."[10] Given the political context of the fable Zeng tells in relation to the series, it becomes clear that the artist uses the mask as an instrument for entering into contact with the past.

In remarks to Karen Smith, Zeng discussed his personal perception of the mask as a complex metaphor beyond that of a barrier between figure and recipient:

In conversation, Zeng Fanzhi reveals that, like Proust, he is consumed by memory, by the habitual act of prompted remembering, of not being able to forget, no matter how or what. . . . Zeng Fanzhi remembers because the period was a tough one, the toughest of his then short life, but one that stuck in his memory far more profoundly and painfully than for any of his contemporaries. [11]

The artist himself links the story of the little red soldier to his own sense of exclusion as a child, when his teacher deemed him unworthy of wearing the coveted red scarf of the Young Communists:

What might seem like a trifling lack to a non-Chinese reader should not be dismissed or underesti-

mated. If we accept Freud's most enduring and credited observation of the impact upon a person of those experiences garnered in their formative years, then given the China context—China under Mao and at the height of the Cultural Revolution—the significance of owning this badge of membership in a society governed by uniform conformity was immeasurable. . . . To be excluded as a child is traumatic in any society. In China within the aura of the Cultural Revolution, it was devastating.[12]

Zeng began the **Mask Series** after moving from his native Wuhan to Beijing. Far from familiar surroundings, in a new and foreign environment, he found himself besieged by old memories and, once again, by the sense of being an outsider. Life in the modern city, with its fascination with Western fashion and its anonymous masses, was the backdrop against which the artist's personal exorcism became a metaphor for Chinese society in the aftermath of Mao.

For Zeng, the mask became a formula for a figure of unspecific age and experience, able to exhibit emotions such as amusement, surprise, and thoughtfulness but never capable of more than display—and as such presenting a fundamental challenge to the possibility of empathy. Like Yue, Zeng draws on one of the original functions of the mask in ancient cultures and primitive societies: to filter memory and process traumatic experience (guilt, helplessness, defeat). His work deploys the mask to banish the past.

Zhang Xiaogang: The Public Image

A masklike symmetry also characterizes the faces in Zhang Xiaogang's series of single and family portraits. The starting point for the **Bloodline** series (see pl. 26) was a stiffly posed photograph of his parents from the 1950s. Traces of his mother's elongated face, with its narrow chin and wide-set eyes, are found in most of Zhang's figures, and an essential similarity connects all of his subjects, male and female.

Though originally inspired by family photographs, the artist has distanced himself from the individual, looking instead for formulas to illustrate the links that connect people in society. A razor-sharp line, Zhang's "bloodline," runs from figure to figure, representing the fundamental relationship between all people. The artist notes:

We are all acting a role that others would accept. A public image, so to speak. What is interesting is the ambiguous relationship between this role and the person's character; the two contradict each other. But we all learn to play this role, thus forming contemporary man's character. This means one must find a balance between that which is public and that which is private. If one cannot bear this balance, then one goes mad.[13]

For Zhang, the way to the *Bloodline* series passed through several surrealist-influenced painting sequences in the 1980s—enigmatic scenes composed of severed heads and masks. Here, the powers of the mind seem to have dissociated themselves from the body to lead separate lives as masks. In the *Bloodline* paintings Zhang uses very intense portraits to develop a formula that sets his own subjective experience—or rather, that of his family—against external projections. The masklike countenance becomes an incarnation of the public image. Clear, bright eyes catch the light and peer through sharply drawn lids, seeming to impart a soul to the softly blurred faces and expressing something like vulnerability, melancholy, or perhaps mourning.

And yet when the figures are considered side by side, their delicate shells repel any attempt to discern individuality. The artist perceives the individual as an unassailable bastion: one may perceive a public image but nothing more.

The Mask As Protection

Masking traditions, from those depicted in Stone Age wall paintings to today's carnival celebrations, derive from a desire to transcend from the subjective to the objective, to appropriate the powers of certain beings through representation or to protect the self from menacing forces through concealment and disguise. We hide our impotence behind a mask and hope the facade will enable us to rise above our own limitations. The mask conceals the wearer's identity and substitutes it with another; in this sense masks are always somehow subversive. Under the cloak of anonymity—or aspiring to supernatural or apotropaic powers—the wearer challenges conventional authority. In archaic hunting magic the mask enabled the hunter to slip in among his prey; later it let the wearer assume godlike powers through ritual. Today the wearing of a mask during demonstrations or with the intent to intimidate is considered a punishable offense. The Chinese artists presented here use the mask to invoke this archaic power and its challenge to authority. In doing so, they create a connection to the past that is more than a commemorative record. In contemporary Chinese art, the power of age-old rites is reactivated through the potency of the mask.

Notes

1 Giles Merritt, "China's Slipping Happy Mask," *The Guardian* (London), August 28, 2007.

2 See Li Xianting, "Cynical Realism and Works of Yue Minjun and Yang Shaobin," in *Faces behind the Bamboo Curtain: Works of Yue Minjun and Yang Shaobin* (Hong Kong: Schoeni Art Gallery Ltd., 1994).

3 See John W. Nunley, "Prehistory and Origins," in *Masks: Faces of Culture,* by John W. Nunley and Cara McCarty (Saint Louis: Saint Louis Art Museum; New York: Abrams, 1999).

4 See Yves Créhalet and Luc Berthier, *Le masque de la Chine: Les masques de Nuo, ou, La face cachée du dernier Empire* (Arles: Actes Sud, 2007).

5 See Éric Boudot with Philippe Fatin, "Ritual Masks of Nuo Exorcism Performance," *Tribal Art* XI–3, no. 44 (Spring 2007): 116–31.

6 Consider, for example, Joseph Beuys, who identified the functions of the artist with those of the shaman in numerous actions. See Martin Müller, *Wie man dem toten Hasen die Bilder erklärt. Schamanismus und Erkenntnis im Werk von Joseph Beuys* (PhD diss., University of Cologne, 1994; Alfter, Germany: VDG Verlag und Datenbank für Geisteswissenschaften, 1994).

7 Madeleine Panchaud, "Yue Min Jun," in *Mahjong: Contemporary Chinese Art from the Sigg Collection,* ed. Bernhard Fibicher and Matthias Frehner (Ostfildern-Ruit, Germany: Hatje Cantz, 2005), 138.

8 See Boudot.

9 Yue Minjun: "We are in a world full of idols. We see them everywhere. Liu Huian, Lei Feng, Michael Jackson, Marilyn Monroe, Picasso, Stalin and so on and so forth. They stand erect in your heart and your life is under their influence and control. I discovered what each of these people as an idol share[s] in common; spreading his or her image everywhere. Just occasionally I simplify and use this method in my art, repeatedly idolising myself. I long to be an idol, because once a person becomes an idol, he or she can enter into the blood veins of others and control their ideology. . . . Life has become tasteless and absurd because of the idols. Do you not think one should counter and ridicule idols with a hearty laugh?" Quoted in *8+8-1: Selected Paintings by Fifteen Contemporary Artists* (Hong Kong: Schoeni Art Gallery Ltd., 1997), 50.

10 Ibid., 20. The thirty-two panels of the *Class One Series* are reproduced on pages 22–23 of that book.

11 Karen Smith, "All That Meets the Eye: Zeng Fanzhi's Art, 1990–2002," http://www.shanghart.com/texts/zfz9.htm (accessed February 19, 2008).

12 Ibid.

13 Shu Kewen, "Create Brands for Art, Interview with Zhang Xiaogang," *Sanlian Life Weekly,* no. 15 (2000), quoted in *Umbilical Cord of History: Paintings of Zhang Xiaogang* (Hong Kong: Hanart T Z Gallery; Paris: Galerie Enrico Navarra, 2004), 110.

Heinrich

Life after History

Eleanor Heartney

History is an elusive entity in all cultures, as facts disappear, new interpretations supplant old ones, and societies forget and reconfigure events that shaped the lives of earlier generations. However, some societies regard history as the enemy and work actively to erase it. In his fantasy dystopia *1984,* George Orwell envisioned a society overseen by a Ministry of Truth whose task was in fact to rewrite and falsify history as the dictates of the state required. Though Orwell's invention stakes out an extreme position, a war on the past has been waged in many societies, not least of all China. • Throughout its long history China has undergone episodes of censorship and book burning aimed at obliterating unacceptable versions of the past. Among the most notorious was the Confucian purge of the third century BCE, when the Qin Dynasty systematically destroyed history and philosophy books and buried noncompliant scholars. China's tumultuous recent history—the sweeping destruction of tradition wrought by the Cultural Revolution, the subsequent introduction of capitalist ideas following the death

LIN TIANMIAO [林天苗]
Seeing Shadow No. 12, 2007
detail of pl. 98

of Mao Tse-tung, the rise of the prodemocracy movement and its harsh demolition in Tiananmen Square, and the unleashing of today's intensely promarket economy—has yielded a society for which the past is extremely problematic. This state of affairs is in part a legacy of the Cultural Revolution, which decreed all manner of cultural traditions, historical artifacts, religious practices, and folk rituals to be remnants of a bourgeois mentality that needed to be ruthlessly stamped out. But in contemporary China, history is also the victim of modernization, subject to a society-wide willingness to wipe out the physical and mental traces of the past in exchange for a fast track to the future.

How does one live without history? How does one build a sense of identity when the past has been relegated to the other side of an unbridgeable chasm? Can an individual or a society understand itself without some sense of historical continuity? These are the issues confronted by China's contemporary artists. Their work, which has of late pervaded galleries, museums, and auction houses worldwide, is frequently read as a more or less straightforward critique of an oppressive system or as an opportunistic grab for attention based on a savvy internalization of the principles of the international art market. *Half-Life of a Dream* represents an effort to dig more deeply into the output of contemporary Chinese artists (some well known, others less so), repositioning their production as responses to a series of psychological traumas rooted in their nation's recent history.

China's current art explosion needs to be understood in the context of its system of art education. Since the Revolution, Chinese art academies have been modeled on the postwar Soviet system, organized around a highly academic training regimen that emphasizes life drawing, working from plaster casts of Western art masterpieces, and traditional drawing, painting, and sculpting skills. There is of course an irony here, as academic realism is an imported style with no roots in Chinese traditions. As in the late Soviet Union, where state-sanctioned Socialist Realism made a demigod of Joseph Stalin, official Chinese art has been long dominated by a visual language that stresses heroic and highly realistic narrative scenes of workers in fields or portraits of revolutionary leaders. Meanwhile, the government's elevation of Socialist Realism has been accompanied by the suppression of venerable native traditions such as ink painting. Academies continue to offer this medium as a specialty, but only after students have undergone rigorous training in academic realism. During the Cultural Revolution, in fact, when the state closed schools and sent students and teachers to the countryside for reeducation, it was actually dangerous to be a proponent of prerevolutionary literati painting.

The arrival of the global art market and the embrace of postmodern approaches by avant-garde Chinese artists (though not, it should be noted, by most art schools) have brought these practitioners to the forefront of international attention. In this context, the tropes of Socialist Realism, at least insofar as they fed the discredited Maoist cult of personality, are now considered fair game, and many artists are exploring conceptual tendencies that would once have been viewed as counterrevolutionary. In China, as in the Soviet Union, where "unofficial" artists such as Komar & Melamid and Aleksey Kosolapov mocked the saintly status of Lenin and Stalin, Socialist Realism and academic training have become the background to which avant-garde artists react. Meanwhile, the sense of dislocation and rupture that is the reality of contemporary China has provided artists with a rich source of subject matter. This has created a remarkably vibrant climate for creative endeavor.

It is now possible for Chinese artists to make playful representations of leaders who are safely dead and whose legacies are being officially reevaluated. Sui Jianguo, for example, has produced a number of sculptures that touch on aspects of Maoism. *Legacy Mantle* (2005; pl. 23) is an empty Mao jacket, realized in fiberglass, that suggests the hollowness of the ideology that once dominated China. Sui also addresses the revolutionary leader in *The Sleep of Reason* (2005; pls. 18–21), in which Mao lies unconscious, surrounded by a field of tiny dinosaurs. As suggested by the title, with its reference to Francisco de Goya's famous evocation of human stupidity, the installation critiques the folly of China's utopian dreams during Mao's reign. In a similar spirit, Xu Yihui's *Little Red Books* (2003; pl. 65) is an unceremonious pile of porcelain replicas of Mao's famous book, which literally served as gospel to faithful party members during his lifetime. Liu Wei, meanwhile, readjusts Mao's once-dominant position in paintings that relegate his image to the background of portraits of friends and family members. In *Two Drunk Painters* (1990; pl. 56), for instance, the leader's likeness glowers impotently over a scene of dissipation that runs deeply counter to Mao's vision of revolutionary rectitude and political dedication.

Artists like these have effectively neutralized Mao by rendering him kitsch. However, other practitioners tend to be less sanguine about the traumas inflicted by the Cultural Revolution: families wrenched apart, urban children sent to the countryside for reeducation,

plate 66
ZHANG DALI (张大力)
Demolition, Forbidden City, 1998
Chromogenic print, ed. 1/10
70⅞ × 47¼ in.
Collection of Vicki and Kent Logan

and student members of the Red Guard encouraged to terrorize their elders, humiliating, torturing, and even killing them for suspected ideological impurities. The Cultural Revolution, now completely repudiated even in official circles, continues to linger within the memories of those who experienced it as a fearful nightmare that can never be completely eradicated. These psychological wounds are the subject of Zhang Xiaogang (see pl. 26). His washed-out paintings have the look of stiffly posed family portraits, but the faces of his subjects are strangely blank. Often the figures' uniforms or ties identify them as Communist Party members, suggesting that one effect of the Revolution was to replace family ties with party affiliations. The work plays in part off the fact that the Red Guard frequently destroyed family photo albums because they represented the ascendancy of private associations over social ones. Trauma appears to have erased all emotion from the faces of these bloodless characters. This underscores the artist's conviction that "For me, the Cultural Revolution is a psychological state, not a historical fact"—one whose effects continue to be written in the psyches of the Chinese people.[1]

The sense of spiritual vacuum that permeates Zhang's work is linked not only to the rupture of traditional familial and social structures wrought by the Cultural Revolution, but also to the equally corrosive effects of China's breakneck pace of urbanization and industrialization. In the space of two decades the country has emerged from its status as an agriculturally based, third world nation to become the world's sixth largest economy. This change has been accompanied by tremendous upheaval: the massive relocation of low-skilled workers from the country to new mega-cities; the emergence of income disparities greater than those that existed before the Communist Revolution; a landscape of clogged streets, massive building programs, and pollution levels that verge on catastrophic; and the subsequent dislocation of huge swaths of the urban population. Zhang Dali's interventions address the effects of these physical and social transformations in an environment that is

vanishing before his eyes. He draws graffiti-style heads on the walls of buildings slated for demolition, and then chisels out their outlines. The artist's photographs of these guerrilla actions become testaments to the disappearance of familiar landmarks in the frenzy of urban renewal (see pl. 66). He has also created his heads in a more transportable form, fashioning their outlines out of neon (pl. 54), a medium that underscores the glitzy new urban environment that is rapidly supplanting the gritty old one. More recent works, such as *100 Chinese* (2001; pl. 55), have focused on the migrant workers who are both the agents and the victims of this transformation.

Other artists draw on photographs of China's new urban landscape, reworking them in paintings that inject a personal quality into documentary images. Yan Lei bases his paintings on pictures of the contemporary Chinese cityscape. Manipulated and re-created in oil on canvas, scenes such as *International Landscape (Beijing)* (2001; pl. 91) become strangely illegible and dreamlike. In a similar spirit, Li Songsong approaches his task like a modern-day history painter, transforming photographic images that range from satellite photographs of the disputed island of Taiwan to icons of Chinese power such as the dome of the Great Hall of the People in Beijing. Translated with gestural strokes into paintings, they present a deliberately dispassionate chronicle of the remarkable changes that have taken place in China since the Revolution ended in 1949 (see pls. 86–87). Meanwhile, Li Dafang, who sees himself as a storyteller, creates paintings that have a photographic look and provide glimpses into scenarios that are never fully explained (see pls. 89–90). Characters are set in ambiguous contemporary environments that seem to be in flux, reflecting a China that has become detached from its traditional moorings.

Many artists are producing work that reflects a sense of alienation deriving from the peculiar nature of life in a time of total change. Among them are figures associated with the movement known as Cynical Realism, which emerged in China in the late 1980s. The curator Gao Minglu has described the movement as exhibiting "a free-floating cynicism unrelated to any dogma and uncommitted to any belief system; . . . [the Cynical Realists] have reacted with a sense of humor to the existential situation."[2] However, as time goes on, artists associated with this moniker have come to appear less cynical than haunted by the loss of any stable sense of history or identity. Fang Lijun and Yue Minjun are both regarded as founders of Cynical Realism; their work shares a focus on signature characters devoid of inner life. Fang's paintings present interchangeable bald men whose oddly distorted faces seem frozen in expressions of pain (see pls. 50–52). They are painted in subdued monochromes or in

shades of unnatural pink and blue against indeterminate landscapes or bodies of water. They appear to be floating unanchored in any real place, a quality that seems to extend as well to their impression of psychological dislocation.

Yue's characters have more energy, but they are equally interchangeable and psychologically opaque. Their faces, which the artist describes as self-portraits, are fixed in a state of mirthless laughter (see pls. 29–31, 60). The toothy countenance is sinister enough in a sculpture or a painting with a single figure, but when multiplied it becomes particularly creepy, recalling vintage horror movies in which members of a community are possessed by aliens. The exaggeration evident in the paintings of Yue and Fang is also a feature in the work of Yang Shaobin (see pl. 47). In Yang's hands, however, the existential Chinese everyman loses his distinctness; he is rendered as an amorphous, red-toned blob whose features can barely be discerned. Yang offers a vision of identity on the verge of dissolution.

The breakdown of identity is suggested in another way in the paintings of Zeng Fanzhi, who indicates the internalization of social and economic disruptions via expressionistically painted portraits of well-dressed denizens of modern China whose faces are covered with white masks (see pls. 48, 62). Taking a different tack, Liu Xiaodong deals with the impact of change in terms of generational crisis. Paintings such as *Fat Grandson* (1996; pl. 27) feature expressionless individuals who are too young to remember the Cultural Revolution; their values have been determined instead by the burgeoning capitalist boom of recent years.

If the above-mentioned artists reflect upon mental states associated with the erasure of history, others have shown an interest in reconnecting with their lineage and reconstructing a battered sense of historical identity, even as their attitude toward history remains ambiguous. Ai Weiwei, for instance, uses historical artifacts—some real, some recreated—to comment on the booming market for Chinese antiques and the transformation of history into commodity. For *Colored Vases* (2007; pls. 71–72) he applied bright, candy-colored paint to authentic ancient vessels; for other projects he has smashed or replicated dynasty ware and reconfigured antique furniture, making installations of wooden doors and windows from destroyed houses of the Ming and Qing periods.

In a similarly ambivalent spirit, Gu Wenda has created a series of "monuments" in which human hair is shaped to create pseudo-languages. To an outsider's eye, *united nations—babel of the millennium* (1999; pls. 94–95) may seem to resemble written Chinese, English, Hindi, and Arabic, but it is actually nonsensical to speakers of those languages.

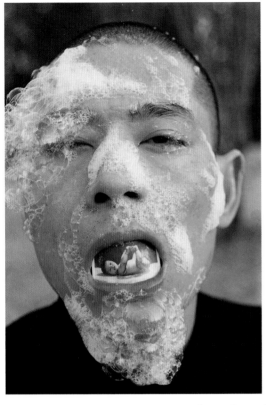

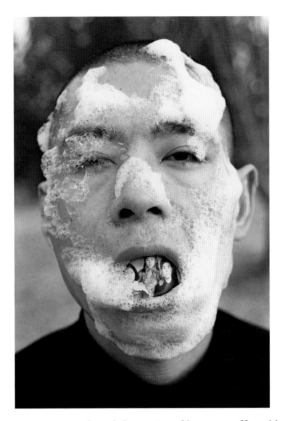

plate 68
ZHANG HUAN (张洹)
Foam (4), 1998
Chromogenic print, ed. 3/15
40 ¼ × 27 ¼ in.
Collection of Vicki and Kent Logan, fractional
and promised gift to the San Francisco
Museum of Modern Art

plate 67
ZHANG HUAN (张洹)
Foam (1), 1998
Chromogenic print, ed. 5/15
41 × 27 in.
Collection of Vicki and Kent Logan, fractional
and promised gift to the San Francisco
Museum of Modern Art

The work may be a comment on the subtle erosion of language effected by propaganda or on the untransmittable nature of tradition in post–Cultural Revolution China. But it also suggests a celebration of the linguistic chop suey emerging from the fusion of cultures and languages in the global community.

Other artists try to re-create history on a more personal level. Zhang Huan's *Foam* series (pls. 67–68) is a commemoration of his family lineage. The photographs record a performance in which he covered himself with white suds, as if newly born and purified. In each picture he opens his mouth to reveal a snapshot of members of his own or his wife's family. Thus he reaffirms the importance of family connections rendered tenuous during his adolescence, in the years of the Cultural Revolution. He has also begun to explore Buddhist symbolism in recent works, recuperating a form of imagery that was long forbidden in China. In *Buddha Never Down* (2003; pl. 104) a sculpture of the artist as a kind of Buddha figure appears within a large spherical cage. When pushed it returns to an upright position, suggesting the irrepressibility of spiritual traditions. Sheng Qi, meanwhile, has

Heartney

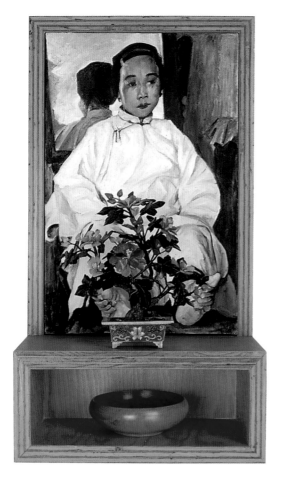

plate 69
LIU HUNG [刘虹]
Bonsai, 1991
Oil on canvas, wood, and jade
25 ⅛ × 14 × 8 in.
Courtesy Rena Bransten Gallery, San Francisco

inscribed history onto his own body. Following the 1989 massacre at Tiananmen Square, he cut off his finger, buried it in a flowerpot in Beijing, and then fled the country, leaving a part of himself behind. ***My Left Hand*** (2004; pl. 103) upholds the artist's permanent disfigurement as a memorial of a traumatic historical event that remains largely unacknowledged by the current Chinese government.

A focus on the impact of China's recent history on private life is particularly marked in the work of several women artists. Yu Hong mingles autobiography and larger cultural events in paintings that pair historical photographs with family snapshots (see pl. 93). She often includes images of her own daughter, thus celebrating the continuation of tradition through family. The works of Lin Tianmiao, meanwhile, have a delicate, poetic interiority far removed from the satirical presentations of many of her male counterparts. She uses white thread, strands of human hair, or fields of Styrofoam balls to form translucent scrims that partially veil images and objects associated with femininity and domestic life. Pointing to the hidden realities of the private sphere, these obscured elements include two- and three-dimensional self-portraits, children's toys, bicycles, and photo-based images of a vanishing rural world. Lin's veiling also is evident in her sculpture ***Initiator*** (2004; pls. 96–97), in which a large frog holds a mass of flowing threads falling forward like hair from the head of a standing woman. The threads are at once protective and confining, suggesting that female roles in contemporary China remain caught up between the restraints of tradition and the uncertainties of postrevolutionary reality. The frog is similarly enigmatic, implying a connection to nature or to the subjective world of dreams that seems increasingly fragile in contemporary China's breakneck rush toward the future.

Another woman artist, Liu Hung, creates paintings based on historical photographs from the nineteenth and twentieth centuries, many of them preserved at great risk by individuals during the Cultural Revolution. Generally they focus on women; subjects include prerevolutionary prostitutes, mothers and children, laborers, revolutionaries, and modern

young women in the years before the uprising (see pl. 69). The artist renders these figures sensuous and beautiful through a painterly technique that blends the realism she learned as an art student in China with gestural marks that evoke both traditional Chinese brushwork and Western abstraction. Even more personal is *We Have Been Naught, We Shall Be All* (2007; pl. 85), part of a recent body of work related to the Sino-Japanese war and based on *Daughters of China,* a Chinese film from 1949 that tells the tale of eight female soldiers who heroically sacrificed their lives so that a larger group of anti-Japanese forces could escape. During the artist's childhood, teachers held these characters up as exemplars of the ideal revolutionary woman; the paintings and related video (pls. 80–84) draw as much on Liu's own childhood identification with the soldiers as they do on the historical record.

Half-Life of a Dream presents a view of China that is far removed from media depictions of a country in thrall to a ruthless and well-oiled economic machine. Revealing the internal dislocations and psychological complexities that are an inseparable part of contemporary Chinese identity, the artists here struggle with a past and present whose outlines are unclear. They express the uncertainties of life in a world in which history itself is uncertain, exploring the peculiar texture of social relations in a society that was once bound by tradition but whose customs are now fading memories. Their work, so full of irony, ambiguity, humor, and melancholy, is a report from a zone where nothing seems certain except, perhaps, the continuing presence of instability.

Notes

1 Zhang Xiaogang, from an interview with the artist conducted by Francesca dal Lago for the Legacy Project, http://www.legacy-project.org/index.php?page=art_detail&artID=865 (accessed January 3, 2008).

2 Gao Minglu, "From Elite to Small Man: The Many Faces of a Transitional Avant-Garde in Mainland China," in *Inside Out: New Chinese Art,* ed. Gao Minglu (San Francisco: San Francisco Museum of Modern Art; New York: Asia Society Galleries; Berkeley: University of California Press, 1998), 155.

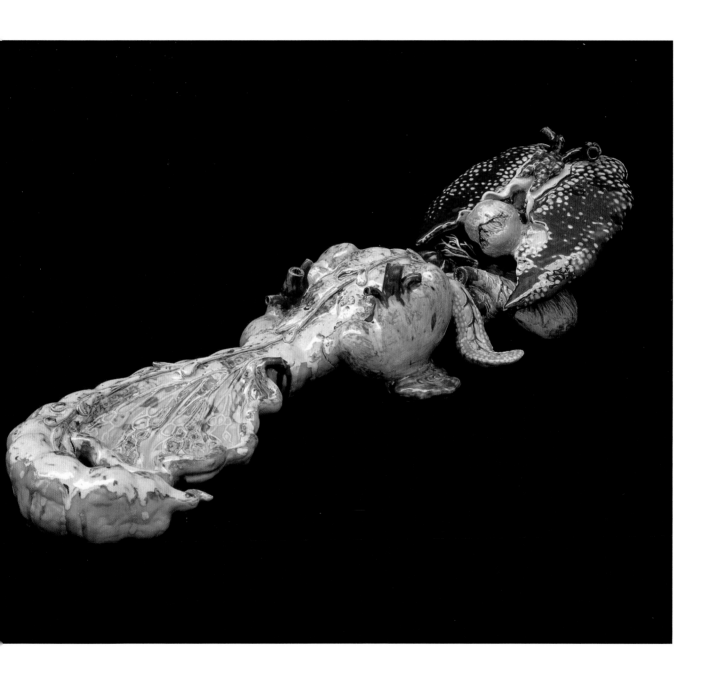

plate 70 AI WEIWEI (艾未未) *Ruyi*, 2006 Porcelain 5 ⅛ × 30 ⅜ × 9 in.

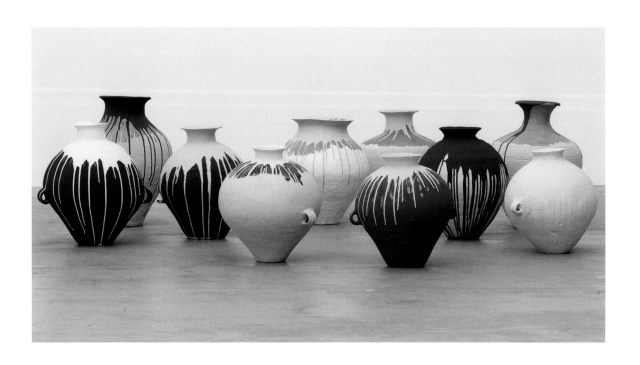

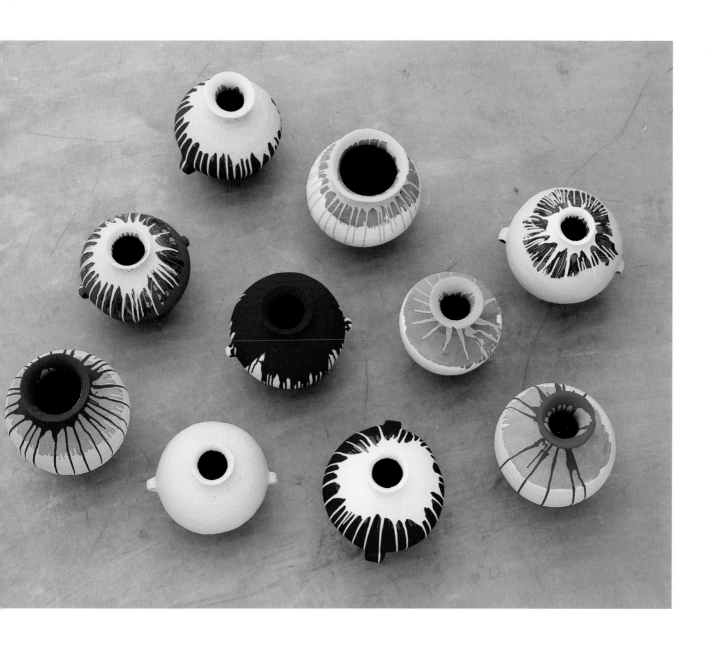

plates 71–72 AI WEIWEI [艾未未] *Colored Vases*, 2007 Industrial paint and Neolithic clay Ten pots, dimensions variable

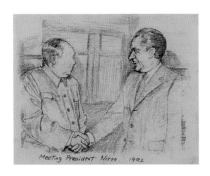

Meeting President Nixon. 1972

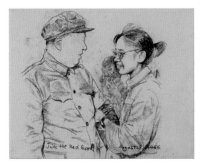

Join the Red Guard. August, 1966

With the Indonesian President, Sukarno. 1961

Meeting Khrushchev. August, 1958

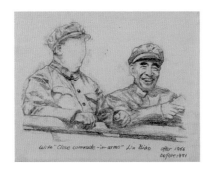

With "Close comrade-in-arms" Lin Biao. after 1966 before 1971

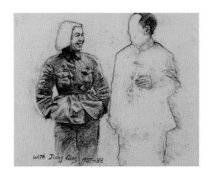

With Jiang Qing 1937-38

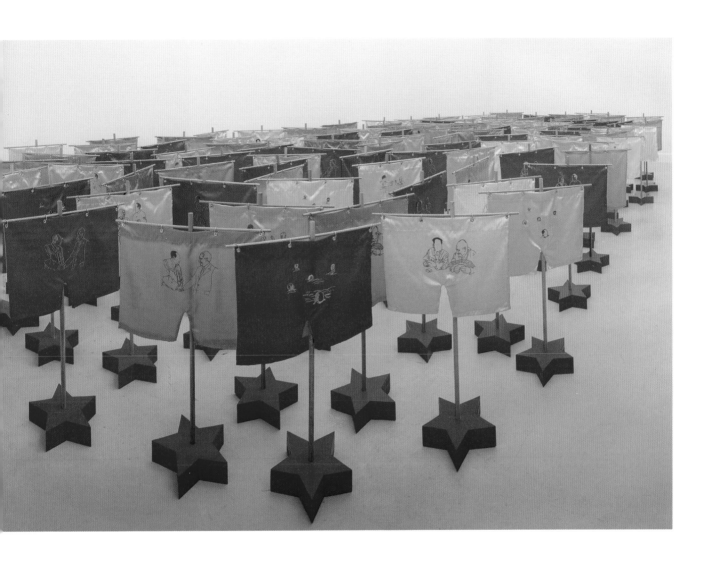

plates 73–79 LIU HUNG〔刘虹〕 *Where Is Mao?*, 1989–2000 Graphite on canvas, wood, embroidered silk, electric fans, and enamel
Dimensions variable

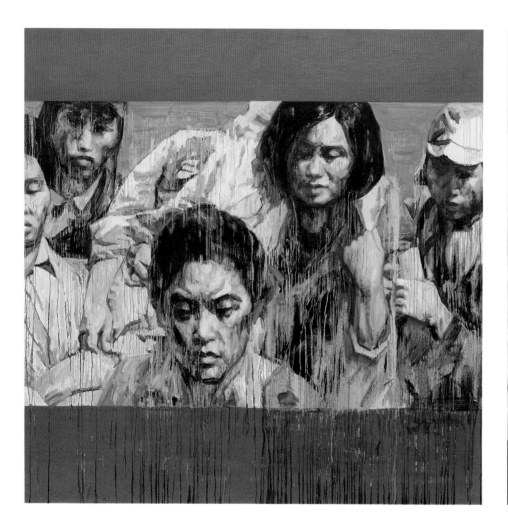
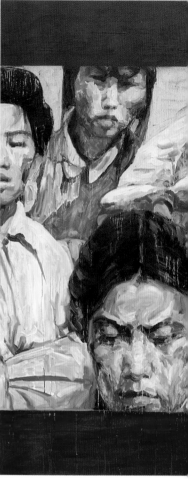

plates 80–84 LIU HUNG 〔刘虹〕 *Daughters of China,* 2006 Single-channel video, 5:27 min.

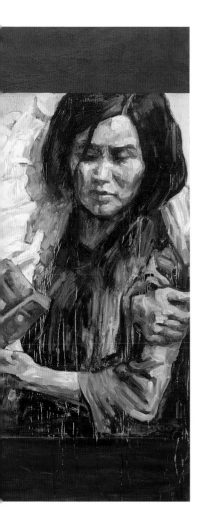
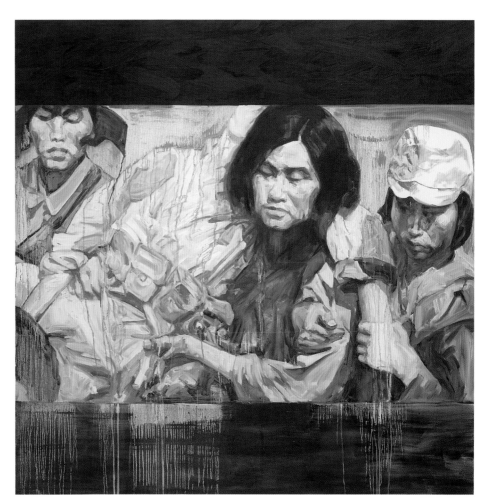

plate 85 LIU HUNG 〔刘虹〕 *We Have Been Naught, We Shall Be All,* 2007 Oil on canvas Three panels, overall: 72 × 240 in.

plate 86 LI SONGSONG [李松松] *Someday My Prince Will Come,* 2007 Oil on canvas Two panels, overall: 98 ⅜ × 173 ¼ in.

plate 87 LI SONGSONG 〔李松松〕 *The Meek Shall Inherit the Earth,* 2006 Oil on canvas 78 ¾ × 141 ¾ in.

plate 88 CUI GUOTAI (崔国泰) *The Wreckage of the Train,* 2006 Acrylic on canvas 70 7/8 × 70 7/8 in.

plate 89 LI DAFANG [李大方] *Little Snow,* 2007 Oil on canvas 74 ¾ × 137 ¾ in.

plate 90 LI DAFANG [李大方] *Elevator,* 2007 Oil on canvas 78 ¾ × 118 ⅛ in.

plate 91 YAN LEI (颜磊) *International Landscape (Beijing)*, 2001 Acrylic on canvas 51 ⅜ × 66 ⅞ in.

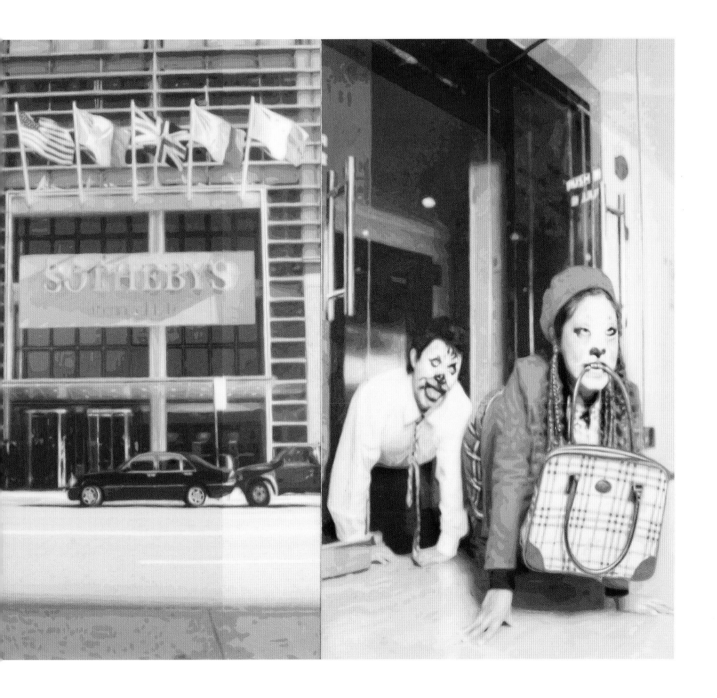

plate 92 YAN LEI (颜磊) *Super Lights—Dog Year New York*, 2006 Oil on canvas Two panels, overall: 102 ¼ × 78 ¾ in.

plate 93 YU HONG 〔俞红〕 *She—White Collar Worker,* 2006 Acrylic and chromogenic prints on canvas Three panels, overall: 59 × 196 ½ in.

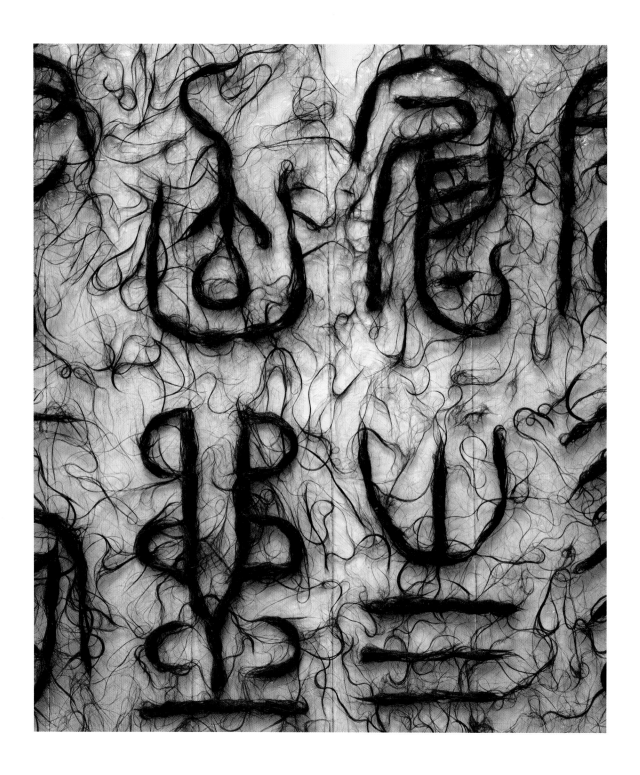

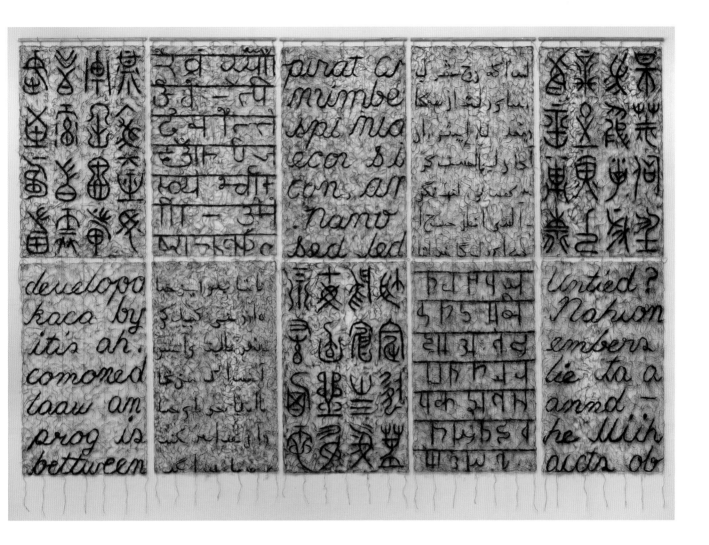

plates 94–95 GU WENDA {谷文达} *united nations—babel of the millennium,* 1999 Hair, glue, and rope Ten of 116 panels, each: 78 × 48 in.

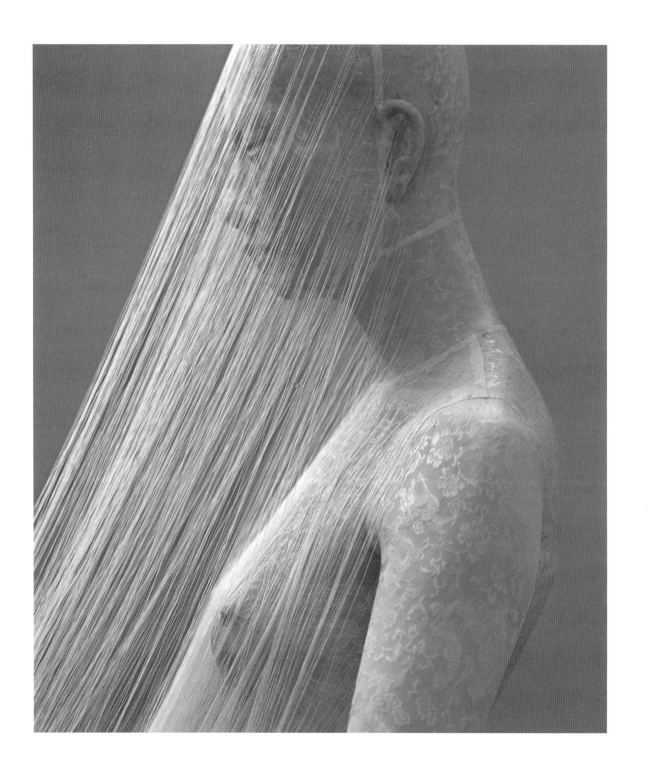

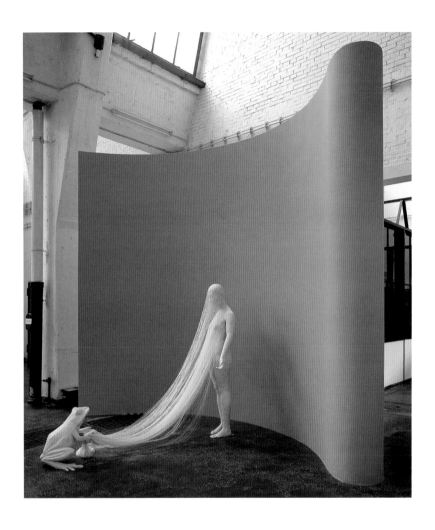

plates 96–97 LIN TIANMIAO [林天苗] *Initiator,* 2004 Fiberglass and silk 66 ¼ × 39 ¼ × 48 in.

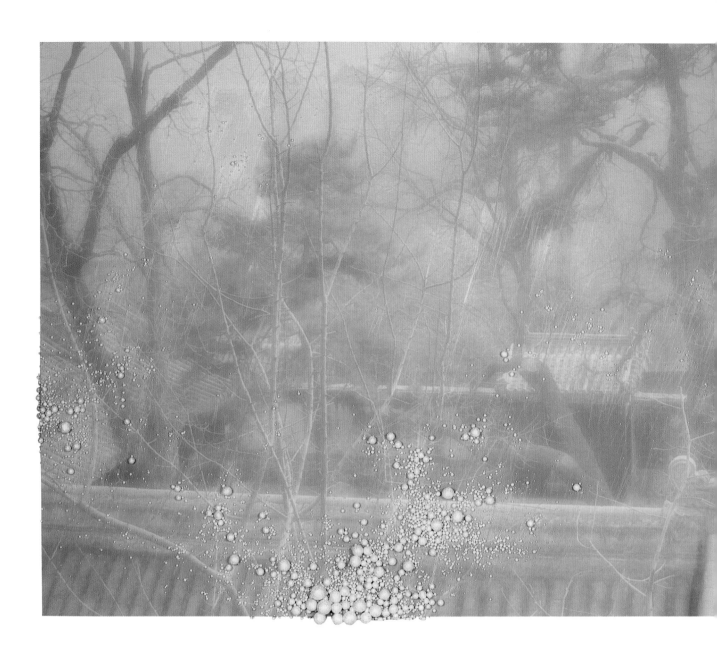

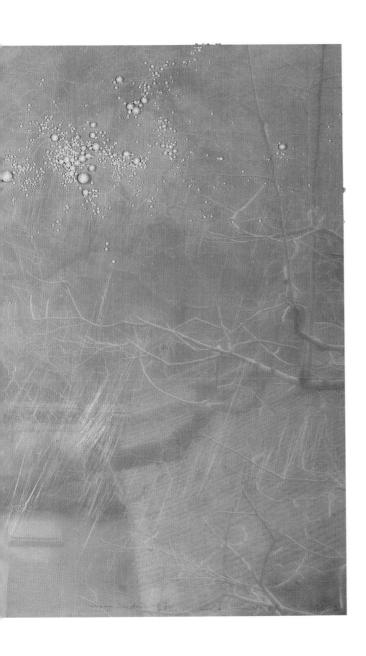

plate 98 LIN TIANMIAO 〔林天苗〕 *Seeing Shadow No. 12,* 2007 Ink and silk thread on canvas 56 ¾ × 111 ¾ in.

plate 99 LIN TIANMIAO [林天苗] *Seeing Shadow No. 20,* 2007 Ink and silk thread on canvas 56 ¾ × 111 ¾ in.

plate 100 ZHENG LI {郑力} *Same Way, Different Direction,* 2004 Oil on canvas 59 × 59 in.

plate 101 ZHENG LI (郑力) *Little Church,* 2004 Oil on canvas 78 ¾ × 59 in.

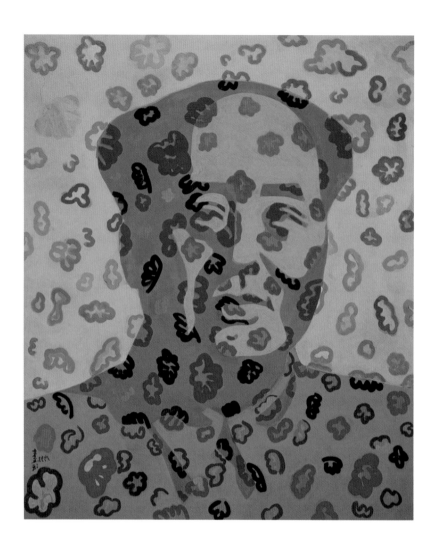

plate 102 YU YOUHAN 〔余有函〕 *Mao Decorated,* 1993 Acrylic on canvas 46 ⅛ × 38 ¼ in.

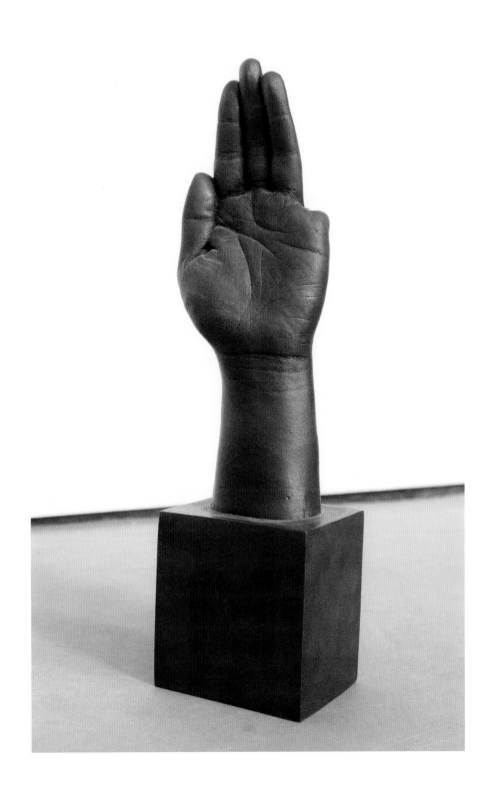

plate 103 SHENG QI (盛奇) *My Left Hand,* 2004 Bronze 14 ¼ × 4 × 3 ⅛ in.

plate 104 ZHANG HUAN (张洹) *Buddha Never Down,* 2003 Metal and fiberglass 83 × 83 × 83 in.

plate 105 ZHANG HUAN [张洹] *Yang Hucheng,* 2007 Incense ash, charcoal, and resin on canvas 98 ⅜ × 63 in.

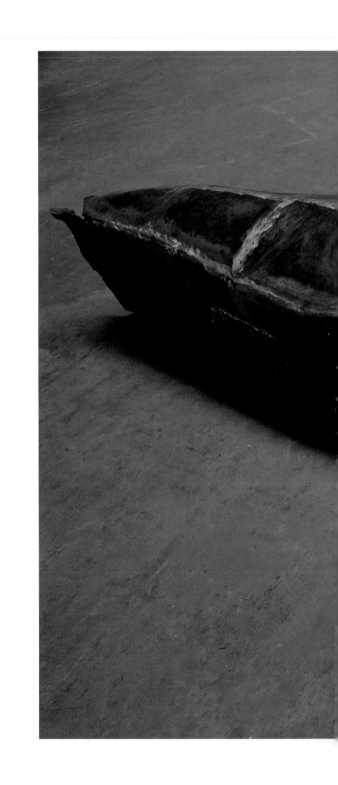

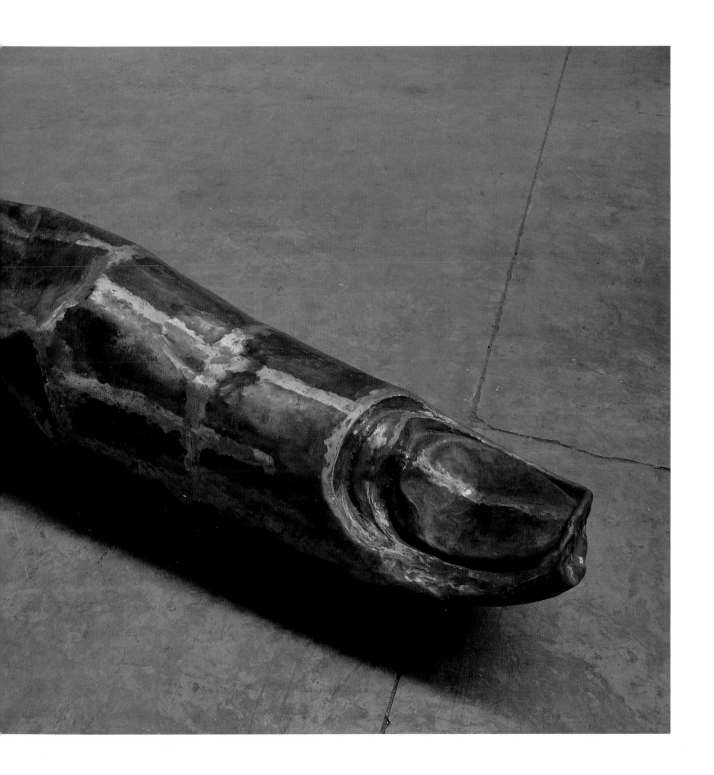

plate 106 ZHANG HUAN (张洹) *Buddha Finger (10)*, 2006 Copper 20 ½ × 24 ⅜ × 108 ⅝ in.

Contemporary Chinese Art:
The Challenge of Transition

Kent Logan

It was nearly ten years ago, in 1999, that the San Francisco Museum of Modern Art hosted the groundbreaking exhibition *Inside Out: New Chinese Art,* which was jointly organized by SFMOMA and the Asia Society Galleries, New York. By that time Vicki and I already had been collecting contemporary Chinese art for several years. In fact, we commissioned the powerful, site-specific hair piece by Gu Wenda, *united nations—babel of the millennium* (1999), that adorned the main staircase at SFMOMA; in addition, we lent several important paintings by Fang Lijun, Su Xinping, and Song Yongping, all of which became part of a promised gift of thirty-eight Chinese artworks to SFMOMA's permanent collection the same year. Thus, it seems particularly appropriate that the first large-scale exhibition of contemporary Chinese art from the Logan Collection—*Half-Life of a Dream,* organized by Jeff Kelley—

should be held at SFMOMA. • The timing of this show also seems propitious, as it comes at a time when, in my opinion, contemporary Chinese art is struggling with transition. Several recent survey exhibitions have thoroughly

GU WENDA (谷文达)
united nations—babel of the millennium, 1999
see also pls. 94–95

documented the last decade of Chinese art, including the now-familiar Political Pop and Cynical Realism movements. However, as important as these styles have been in establishing an authentic, initial signature for this period, they now seem to have run their conceptual course. Though several significant pieces, particularly in the Cynical Realism genre, are included in this exhibition because of their precedent-setting, influential nature, the goal of *Half-Life of a Dream* is to look forward to the next ten years (although admittedly the crystal ball is hazy).

Notwithstanding the meteoric rise in the price of art by a number of these "first-generation" artists since the March 2006 auction of contemporary Chinese art by Sotheby's in New York, there is a surprisingly shallow understanding of the conceptual basis of much of the work on the part of American collectors and curators. To a great extent this reflects the fact that there are only a handful of museums of contemporary art in China, very few Chinese curators and critics, and, until recently, virtually no meaningful, supportive dealer relationships in place. The only museum shows that have taken place in the United States since *Inside Out* are the 2005–6 exhibition *The Wall: Reshaping Contemporary Chinese Art,* organized by the Albright-Knox Art Gallery in Buffalo, New York, the University at Buffalo Art Galleries, and the Millennium Art Museum in Beijing, and the 2007 *Red Hot: Asian Art Today from the Chaney Family* at the Museum of Fine Arts, Houston. (It should be noted that there have been a number of museum exhibitions devoted to important individual artists, such as Zhang Huan, Cai Guo-Qiang, Liu Xiaodong, Liu Hung, Sui Jianguo, and Zhan Wang.) Given that China represents one-third of the globe's population and can boast of having several of the world's finest art academies, as well as a centuries-old tradition of excellence in the visual arts (not to mention the fact that it is rapidly emerging as *the* superpower of the twenty-first century), it seems to me that its importance as a center for contemporary art over the next twenty years is unquestionable.

China's ongoing transformation and its integration into the new world order is arguably the first watershed event of the millennium. Though China's artistic roots go back centuries, the era of Socialist Realism and the traumatic decade of Mao Tse-tung's Cultural Revolution caused a radical disjuncture. Not until the *China/Avant-Garde* exhibition opened in February 1989 at the National Art Gallery in Beijing was free artistic expression again publicly acknowledged on home ground. Tragically, the brutal repression that June of the student democracy movement in Tiananmen Square stunned the arts community. However, it also galvanized intellectuals and artists outside China, resulting in increased

attention to the ways in which Chinese art reflected important political and social issues as the society evolved in the 1990s. Given the magnitude of the change that China will inevitably undergo over the next two decades, it is particularly important to us that the nation's art be an integral part of our contemporary collection.

A New Chinese "Modernism"

In many ways, the death of Mao in 1976 ushered in the "modern" period of Chinese art. The Cultural Revolution, with its complete subservience to Mao's thoughts and ideas, gave way to a flurry of new political, cultural, and economic initiatives from Deng Xiaoping, with a particular emphasis on opening a dialogue with the West. After decades of isolation, the artistic community fervently embraced these new freedoms. As Gao Minglu, the principal curator of *Inside Out,* stated in his catalogue essay:

Based on its goal of enlightenment, artists of the '85 Movement . . . claimed that art has nothing to do with technique or style but should directly express ideas. For example, the manifesto of the influential North Art Group said, "Our painting is not art anymore but part of our complete new thought."[1]

Although artists were, in effect, the avant-garde of this 1980s Chinese renaissance, the forces unleashed by Deng's new policies had broad ramifications throughout society. Many artists pressed for a clean break with the past and with socialist ideology, which had suppressed any individuality or creativity that was not state sanctioned. Ma Desheng, one of the founders of the avant-garde Star group, stated: "Every artist is a star. . . . We called our group Stars to emphasize our individuality. This was directed at the drab uniformity of the Cultural Revolution."[2]

The idealism of the 1980s democracy movement reached its zenith for the Star group with the opening of the radical *China/Avant-Garde* exhibition under the slogan "No U-Turn." However, no sooner had it opened than Chinese authorities shut it down after the artist Xiao Lu fired two pistol shots into her own installation. Just three months later, the June 4 incident in Tiananmen Square punctuated the end of a decade of idealism and optimism. In the wake of these events, many artists in the Star movement emigrated, while those who stayed behind

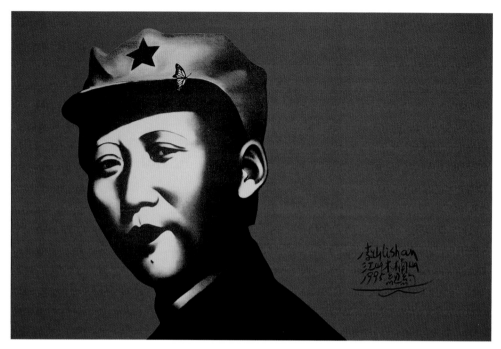

plate 108
LI SHAN (李山)
Rouge Series: Young Mao, 1995
Silkscreen and acrylic on canvas
43 × 65 in.
Collection of Vicki and Kent Logan, fractional
and promised gift to the San Francisco
Museum of Modern Art

abandoned their grander utopian visions and focused instead on the emerging official doctrine of economic liberalization. This shift in attitudes resulted in the well-documented rise of the post-1989 artistic styles known as Political Pop and Cynical Realism, which to my mind ushered in the "contemporary" period of Chinese art.

In effect, the two styles document the broad shift from a predictable and (ironically) stable communist society to a quasicapitalist one, with all of its subsequent dislocations and uncertainties. Viewed in this light, Political Pop was more about popular culture than politics. It had much in common with the American Pop movement of the 1960s, just as Cynical Realism had much in common with the multiculturalism dialogue in American art of the 1980s as well as the identity art of the late 1980s and 1990s. In a sense, forty years of contemporary Western art were squeezed into only a decade of contemporary Chinese practice.

American Pop of the 1960s mirrored the culture of the time: postwar prosperity, the emergence of a middle class with a voracious appetite for new consumer goods, and a fascination with mass media, advertising, and celebrity. In short, the 1960s ushered in a new era of American materialism. Certain consumer goods became symbols of the decade; wealth became a sign of the times. Fast-forward thirty years and substitute post–Cultural Revolution China, with Deng's economic liberalization program, the rise of commercialization and mass

plate 110
THE LUO BROTHERS (罗氏兄弟)
Welcome to the World's Famous Brands No. 15, 1997
Lacquer and paint on wood
25 ½ × 21 ⅝ in.
Collection of Vicki and Kent Logan

plate 109
WANG GUANGYI (王广义)
Great Criticism: Pierre Cardin, 1993
Oil on linen
58 ½ × 46 ⅞ in.
Collection of Vicki and Kent Logan, fractional and promised gift to the San Francisco Museum of Modern Art

culture, Socialist Realism propaganda turned art, and Mao as the ultimate celebrity. The outline of 1990s China looks remarkably similar to America in the 1960s.

Rather than being aggressively critical of the Cultural Revolution, most Political Pop artists seem ambivalent—even nostalgic—about that period. Mao is glorified, not vilified, and may arguably have become the most powerful portrait subject of the twentieth century. Yu Youhan painted Mao over and over again, often on textiles and overlaid with flowery forms symbolic of the "peasant art" Mao favored (see pl. 102). Li Shan's *Rouge Series: Young Mao* (1995; pl. 108) idealizes Mao's image to convey modern youthful energy and vitality (symbolic of the new China's hope for the future). Both approaches recall Warhol's iconic series of portraits of Marilyn Monroe, Elvis Presley, and Jackie Kennedy. The importance of these artists' work lies not only in their style and subject, but also in the fact that Mao and Marilyn are, as the critic Lawrence Alloway put it, loaded images of "precoded material" that function simultaneously as documents of popular culture.[3]

Wang Guangyi's *Great Criticism* series also epitomizes this transitional period in Chinese culture. The works juxtapose portraits of Communist workers with logos of instantly recognizable consumer brands, such as Coca-Cola, Marlboro, and Pierre Cardin (see pl. 109). By using symbols representing the socialist and capitalist systems in a single composition, Wang alludes to the perceived imperfections of both, reflecting the rampant skepticism that enveloped Chinese society in the 1990s. His work calls to mind Warhol's images of Coca-Cola bottles, Brillo boxes, and Campbell's soup cans as well as the early paintings of Tom Wesselmann and James Rosenquist.

The Luo Brothers' series *Welcome to the World's Famous Brands* juxtaposes the optimism of Asian economic progress with a warning about the associated dangers. As Reena Jana has pointed out, *Welcome to the World's Famous Brands No. 15* (1997; pl. 110) offers yet "another commentary on the rise of the money culture":

The artists present an exuberant yet disturbing image of a Chinese baby amidst ancient and modern symbols. In traditional Chinese art, young children symbolize high parental hopes. . . . This baby playfully rides a tiger, a Chinese symbol not only of strength and courage but also of the West. . . . The baby lifts a giant Oreo cookie. . . . The baby and the tiger are on a bed of chrysanthemums, a traditional symbol for the longevity of a person with excellent character and a metaphor for the sense that everything occurs in its proper time. [4]

The headlong rush toward wealth and materialism in 1990s China followed decades of subservience to Communist doctrine. Compounded by the disillusionment that followed

the short-lived utopian idealism of the 1980s, this inevitably produced a general sense of malaise concerning the individual's role in contemporary Chinese society. The pervading sense of helplessness or indifference became the source of the rogue pessimism reflected in the art of the so-called Cynical Realists.

Born in the late 1950s and early 1960s, most Cynical Realists were still students at the time of the *China/Avant-Garde* exhibition. In many ways this was the generation whose aspiration was most crushed by Tiananmen, and it is their work that has become the foundation for contemporary Chinese art going forward. Zhang Xiaogang's *Bloodline* series (see pl. 26) vividly captures these artists' resignation and criticism. The portraits, which typically depict the ideal Red Guard model of a three-member family (father, mother, and one child), skillfully comment on the banality of post-1989 Chinese society by presenting figures that appear generic, impersonal, inbred, and effeminate, in stark contrast to the heroic revolutionaries of the past decade. Faces and expressions are devoid of individual personality—a subtle, cynical reference to the suppression of individual desire in deference to the collective whole. The thin red "bloodline" that runs through the portraits alludes to the inescapable fact that each person or family has memories and a history that will inevitably reassert themselves as authoritative constraints on society are relaxed.

Though Zhang was one of the first artists to articulate the sense of helplessness in the post-Tiananmen era, none has captured the absurd, mundane, and meaningless events of everyday life better than Fang Lijun, a painter of biting self-portraits (see pls. 50–53). As Wu Hung, chief curator of the first Guangzhou Triennial, stated so eloquently:

Self-portraiture . . . constitutes an important genre in 1990s experimental art. A common tendency among experimental artists, however, is a deliberate ambiguity in portraying their likeness, as if they felt that the best way to realize their individuality was through self-distortion and self-denial. A particular strategy for this purpose—self-mockery—became popular in the early 1990s, epitomized by Fang Lijun's skinhead youth with an enormous yawn on his face. A trademark of cynical realism, this image encapsulated a dilemma faced by Chinese youth in the post-1989 period, and introduced what may be called an "iconography of self-mockery."[5]

Fang (who himself has a shaved head) describes himself as a rogue and a painter of loss, ennui, and crisis. Li Xianting, in his essay for the catalogue *Fang Lijun: Human Images in an Uncertain Age,* quotes the writer Lin Yutang in his discussion of the rogue in post-Maoist China: "'Today when liberal freedoms and individual freedoms are threatened, perhaps only the rogue or the spirit of the rogue can liberate us, so that we do not

all end up as disciplined, obedient, and regimented soldiers in the same uniform and with the same rank and number in one big army.' The rogue is the last and staunchest enemy of authoritarianism."[6]

Fang's use of figures isolated in vast expanses of water and sky conveys a desire to escape from the mundane existence of everyday life and return to the security of the womb or the dreamlike permanence of death. Through his art he takes very personal memories and experiences and touches on universal themes in contemporary Chinese life: the feeling of individual insignificance and the difficulty of defining personal identity in a postmodern world.

Thus it is no accident that surrealism seems to have resurfaced in the work of the current generation of Chinese artists. Disillusionment and alienation appear to have been inevitable in light of the combined weight of Mao's authoritarian rule, a brief period of liberalization and freedom, and the subsequent reversion to a different form of socialist political doctrine, heavily diluted by the disorienting influence of Western capitalism and materialism. Perhaps the most powerful example of Chinese neosurrealism is the work of Yue Minjun. Li Xianting has said that Yue's paintings represent a self-ironic response to the spiritual vacuum and folly of modern-day China. The heart of the artist's practice involves repetitive self-portraits, in which he is always laughing and always with eyes closed (see pls. 29–31, 60). The overall impression is one of cynicism with respect to the unfulfilled utopian ideals of the Cultural Revolution and the shallowness of current existence. In effect, Yue is rejecting the reality (past and present) of Chinese society in favor of a more ethereal place suggested by the deep-blue sky and clouds in the background of many of his paintings (reminiscent of Fang's frequent use of deep-blue water). He sums up his own philosophy best: "Laughter is the source of everything. Everything is nonsense, you are a lunatic. Ha, ha, ha."[7]

Conceptual Nostalgia: A Bridge to the Past

Importantly and perhaps ironically, the hallmarks of Cynical Realism—the sense of disillusionment stemming from a feeling of individual insignificance, the widespread cynicism caused by the unfulfilled ideals of a truly egalitarian socialist society followed by the perceived superficiality of China's new, Western-style materialism—have set the conceptual stage for the next chapter of contemporary Chinese art.

It is no coincidence that the first generation of artists focused on the present. Most were born around the time of the Cultural Revolution: Sui Jianguo and Wang Guangyi in 1956, Zhang Xiaogang in 1958, Lin Tianmiao in 1961, Fang Lijun and Liu Xiaodong in 1963,

plates 111–12
LIU HUNG (刘虹)
Where Is Mao? (details), 1989–2000
Graphite on canvas, wood,
embroidered silk, electric fans,
and enamel
Dimensions variable
Collection of Vicki and Kent Logan

and Zhang Huan in 1965. Thus, although they lived through that turbulent period, their experiences were those of young children. By the time they were in their more intellectually formative years as teenagers and had begun to train as artists, Mao had died, Deng was in power, and a sense of optimism and freedom permeated the artistic community. Though China's newfound freedoms would again be curtailed in 1989, it was this succession of events that influenced art making in the 1990s and the first half of the current decade.

While this focus on the present was pervasive, there were nonetheless a number of artists, most born somewhat earlier—Liu Hung in 1948, Gu Wenda and Xu Bing in 1955, Zhang Peili in 1957—who looked to the past as the conceptual foundation for their work. The art of Gu and Xu (see pls. 17, 32, 94–95) is clearly derived from calligraphy, one of the most ancient and venerated forms of Chinese expression. One of Zhang's earliest video works, *Water: The Standard Pronunciation* (1992), references the difficulty of imposing Mandarin as the official Chinese language in a society consisting of fifty-six ethnic groups.

Liu Hung is the oldest of this first wave of contemporary artists and will perhaps prove to be one of the most influential, although she is sometimes overlooked: she cannot be characterized as either a Political Pop artist or a Cynical Realist; she was one of the first to immigrate to the United States, in 1984; and she is a woman—still a rarity in Chinese art circles. Nonetheless, she is widely referred to as "elder sister" by the younger generation of male artists. A mural she painted in the early 1980s in the dining hall at the Central Academy of Fine Arts in Beijing is widely credited as an inspiration for artists who wished to veer away from rigid adherence to Socialist Realism, the stylistic bedrock of the academy's curricu-

lum at the time. Over the past twenty years, her work has repeatedly made reference to the Chinese Civil War, the founding of the People's Republic of China, and turn-of-the century society. The earliest piece in this exhibition is *Where Is Mao?,* a series of ten drawings on canvas completed in 1989 (a collection of miniature vessels with embroidered silk sails was added in 2000; see pls. 73–79, 111–12). In many ways this work set the stage for the art that would follow in the 1990s.

Liu's drawings are taken from famous news photographs of Mao—the Great Leader toasting Chiang Kai-shek, meeting Nikita Khrushchev, with Indonesian President Sukarno, with Communist heir apparent Lin Biao, and famously swimming in the Yangtze River—but in all of the renderings Mao's face has been erased. As Jeff Kelley stated in the catalogue accompanying the exhibition *Where Is Mao? 2000* in Bangkok:

The fact that the artist has erased Mao's face from each of her newsworthy drawings is less a political gesture than a psychological one, a way of signifying the ironically ever-present absence of the father, of identifying the visual site of a vague psychic wound in those who, like herself, grew up in Maoist China beneath the omnipotent, benevolent, and—ultimately—vacant gaze of the "Reddest Red Sun." When juxtaposed against the miniature sailboats, adorned with silk "sails" made from colorful swimming trunks embroidered with images of Mao as head of state, the question is whether China can find its way forward as a state without the steady hand of a now deceased god-like Mao, or whether it is destined to just drift along as a rudderless boat. [8]

Mao the Myth, Mao the Reality

To date, Mao has clearly been the conceptual heart of contemporary Chinese art. There would have been no Political Pop movement without images of Mao or references to the cult of idol worship associated with his nearly thirty years of power. And though the harsh excesses of the Cultural Revolution are not warmly remembered, without that period of suppression, followed by an equally frustrating decade of liberalization and ultimate disillusionment, there would have been no Cynical Realism.

As important as Mao was (and still is), it is critical to put his twenty-seven-year reign in perspective. After all, China is a society that is four thousand years old. Beijing itself has been imperial home to twenty-four emperors over five hundred years; moreover, China has had a rich tradition in the visual arts for thousands of years. This is not to say that the impact of the Cultural Revolution was not devastating—it was. The Cultural Revolution was an attempt to erase the collective memory, and history, of more than one billion people, and

it succeeded to some extent for a time. It is instructive to recall the collective guilt that weighed on the post–World War II German population, which had to accept the destructive actions of Nazism before German society could move forward. The artists Anselm Kiefer and Georg Baselitz were among the first to embrace these issues in their work. Kiefer has been referred to as "the archaeologist of German guilt"—a kind of "Pied Piper leading away the demons of the Third Reich."[9] Baselitz's 1965 *Hero* paintings of partisans and peasants rising out of the ashes of postwar Germany represented the hope that German society could rebuild and regain a sense of respectability and pride.

Ai Weiwei's work similarly attempts to force Chinese society to look at itself in a mirror, not only to come to grips with the hypocrisy of current mores and priorities, but also to expose the continuing abuse of power by the state—a fact of life since imperial times. In a different vein, Liu Hung's recent body of work from 2006–7, *Daughters of China* (see pls. 80–85) reaches back to an important 1949 propaganda film that lionized the sacrifices of a group of women in their heroic struggle to defeat the Japanese in the Sino-Japanese War (1937–45). While the images are derived from the film, the titles of the paintings are taken from the lyrics of "The Internationale," the nineteenth-century French song adopted as the anthem of international socialism. It is a particularly poetic expression of what was good about Chinese values in the 1930s; in effect it acts as a bridge to the past for the current generation of Chinese (those born since 1948), who are still searching for a rationalization of the turbulence that has characterized their society for the past sixty years.

This is not to imply that the abuses of the past will be easily forgotten. In fact, many would argue that they have continued today. Consider China's current headlong rush to urbanize itself through dramatic transformation of the environment (the Three Gorges Dam project or the even more ambitious plan to divert water from the Yangtze River Valley to Beijing and Tianjin), resulting in mass displacement and migration of the population from the countryside to the city. Ironically, at the same time, vast tracts of traditional housing are being demolished in many large cities to make way for new, impersonal apartment blocks and shopping malls, fostering a growing alienation between the "new city" and its "new residents." No artist has captured this more viscerally than Zhang Dali, who has covertly spray painted the profile of a head on numerous walls, buildings, and bridges earmarked for destruction (see pl. 66), thereby generating a dialogue concerning the ultimate fate of displaced individuals being herded about by an indifferent administration (and once again highlighting the issue of the self versus the collective whole in Chinese

society). He took the concept a step further in *100 Chinese* (2001; pl. 55), for which he cast the heads of a hundred migrant workers in the form of death masks. These workers have flocked to Beijing in search of employment, but they have no official status and thus are truly adrift in contemporary China—they are the forgotten face of a society undergoing dramatic urbanization.

Art as a Bridge to the Past

Whereas Political Pop and Cynical Realism have poignantly captured the mood of present Chinese society, the next movement in contemporary Chinese art, perhaps ironically, may be to reach backward and reestablish a link with the rich traditions of prior generations. A number of works in this exhibition reflect a desire to reconnect with the past. The blank expressions of the three comrades in Zhang Xiaogang's *Big Family* (1996; pl. 26), for example, reference the suppression of individual identity in deference to the collective whole. However, the thin red "bloodline" that runs through the portrait pointedly reaffirms the fact that authoritarian fiat cannot eliminate the strong generational bonds of the family, its history, or its future.

Ai Weiwei's *Colored Vases* (2007; pls. 71-72) literally reflects the past; each of the ten pots is from the Neolithic age. Though the objects demonstrate some of earliest abstract brushwork of Chinese artists, Ai has chosen to deface the artifacts by brazenly applying what he describes as Warhol-colored house paint. This apparently irreverent act of ruining valuable artifacts forces a contemporary viewer to reflect upon the deeper philosophical implications of the transgenerational purpose of art making. As Ai stated in an interview with the art critic Britta Erickson in 2006:

The "colored pots" are never colored. They have a long history, and there are so many of these pots. Always they are shown in the context of antiquity, and with great respect. But they can never get into the contemporary art museums, and contemporary art museums' exhibition conditions are much better than the conditions for exhibiting antiquities. . . . Even disrespect itself is respect. . . .

Time will always cover up art—the meaning, too. The people who made those pots enjoyed the moment and enjoyed what they made. I think they would not have thought of themselves as artists, but what they did was almost a religious act, giving shape to mystery. [10]

Ai's sculpture *Ruyi* (2006; pl. 70) similarly reaches back to ancient Chinese custom. One presented a ruyi to a person from whom one was soliciting a favor or support; it was reputed to bring the recipient fortune, luck, and robust health. A ruyi is usually made of wood,

jade, or ivory, but Ai's version is made of porcelain fired in the kilns of the master craftsmen of Jiangxi Province, which has been China's center of porcelain production for centuries. In addition, *Ruyi* is unusually fashioned after the internal organs of the human body, speaking to an unbreakable link between generations of Chinese from ancient times to the present.

The bond between past and present is also the conceptual basis of Yu Hong's *She* series, which combines paintings and photographs. As Zhai Yongming wrote in 2006:

In the She *series . . . Yu Hong has gone away from the narrative of the individual, and investigated the daily lives of all women. . . . "The growth of a nation is juxtaposed alongside with the growth of an individual, the uncharacteristic political life is juxtaposed alongside ordinary life of the individual, the greater historical narrative is juxtaposed alongside the delicate personal moment, and the weight of history is juxtaposed alongside the powerlessness of the individual." . . . From the photographs of these ordinary girls one can see the overlapping of historical memory and personal experience.* [11]

In essence, Yu places individual experience within a broader historical narrative. Typically, the photographs represent an earlier time in the subjects' lives. *She—White Collar Worker* (2006; pl. 93), for example, includes a photo of the subject's mother, further enhancing the idea of generational interconnection over time.

The same ideas—that we cannot escape the past, that all of us are connected by a common cord—are captured in Sui Jianguo's *Impermanence* (2006; pl. 24). The lead sculpture is cast from an actual skull unearthed during excavation of the site of Sui's studio in Beijing. The simple fact that he was sufficiently moved by such a discovery to turn it into an art object suggests a nostalgic sentimentality and a curiosity about the history of the earlier occupants of that precise location.

Taking a Step Backward in Order to Move Forward

It is a well-known fact that many artists—including Liu Hung, Gu Wenda, Xu Bing, Cai Guo-Qiang, Huang Yongping, Ai Weiwei, Chan Zhen, and Guan Wei—emigrated from China in the 1990s. But it is much more interesting to me that a number of them have returned to China, and to their historical roots, over the past several years. One of the most renowned is Zhang Huan, who left China in 1998 to settle in New York but returned to Shanghai in 2006 to set up a vast new studio. It is intriguing that his first body of work since returning draws its inspiration from Buddhism, which made its first appearance in China more than a millennium ago. Zhang's sculpture *Buddha Never Down* (2003; pl. 104)—a self-portrait of the artist encased in a roly-poly, ball-type cage—is similar to a device he used

during a 2001 performance in Santiago, Spain, a town to which Christian pilgrims have come for centuries. As he stated in a 2003 interview, "Art to many people, to me, is another kind of religion. . . . Art lovers, Christians, Buddhists . . . people need a feeling to save themselves, to ease suffering, to live lighter. . . . I appreciate art giving me a living way."[12]

In 2005 Zhang made a trip to Tibet, where he was profoundly moved by tiny fragments of fingers and feet from Buddha sculptures that were destroyed during the Cultural Revolution and are now available for sale in local markets. The experience resulted in a series of copper sculptures resembling Buddha's fingers, feet, and legs, blown up to gigantic scale (see pl. 106). Eleanor Heartney has captured the larger, timeless message of this body of work:

These fragmentary fingers, hands, and feet point to acts of destruction that fail to diminish the continuing vitality of the Buddha's spirit, which lives on in them unimpeded.

The paradox of Zhang Huan's work is a marriage of violence, self-inflicted pain, and physical transgression with a Buddhist-inspired quest for peace and enlightenment. . . . Through acts centered on his own sensate and often suffering body, Zhang Huan hopes to bridge the gap, not just between mind and spirit or nature and culture, but also between individuals and societies.[13]

Zhang followed this body of sculptural work with a series of paintings and sculptures involving the use of incense ash collected from Buddhist temples in Shanghai. To the artist, the ash represents the collective hopes and dreams of all the devout worshippers who light incense sticks and pray at these temples, an ancient ritual that conceptually links all Buddhists, across centuries, who have been part of this community. Further emphasizing the link with the past, the paintings depict historical figures from the Chinese Civil War. *Yang Hucheng* (2007; pl. 105), for example, is a portrait of a general in the Nationalist Army.

The painter Li Songsong also reaches back in time for his source materials; most of his images were derived from newspaper photographs or television broadcasts. *The Meek Shall Inherit the Earth* (2006; pl. 87), which obviously takes its title from a biblical reference, portrays a public execution, but the date and location of the incident are not clear. Because the event is more generic than date-specific, it would seem to reflect the timeless specter of man's inhumanity to man. Likewise, Liu Xiaodong's painting *Xiaomei* (2007; pl. 28) captures the likeness of a woman in a nonspecific, dreamlike state. It is unclear whether she is dreaming of the present, the future, or the past, or even whether the dream is pleasant. She may be a metaphor for the current state of Chinese consciousness, which seems to be caught in a transitional conundrum—wary of the future but still uncomfortable with the past.

Similarly enigmatic is Zhang Xiaogang's *Untitled* (2005–6; pl. 25), which is very similar to works in his *Amnesia and Memory* series. In this painting a man rests his gigantic head on its side, his face illuminated by an inspirational (or not?) lightbulb. A book, which may already have been read or is still waiting to be perused, lies apparently out of reach. The painting implies broad philosophical questions, but Zhang supplies no answers.

No such passive ambiguity clutters the terrifying, bloody images of Yang Shaobin, although they may seem to be the product of dreams—or nightmares. The artist has stated that they are psychological self-portraits reflecting his agonizing time as a member of the public security forces. It is almost as if the images of tormented souls in *Untitled 1999–4* (1999; pl. 47) represent both the artist as an individual and society as a collective whole. The work suggests that the Chinese must expunge memories of authoritarian excess before they can put the past behind them and move forward into the future.

A Cultural Bridge: From Mao to the Future

The Political Pop and Cynical Realism movements keenly documented the issues facing Chinese society, from the Cultural Revolution to the Deng Xiaoping decade and more recent dislocations stemming from China's newfound economic prosperity. The key questions now are where does China go from here and how will societal structures evolve? The challenge for artists going forward will be to build a cultural bridge over the disappointments and disillusionments of the past forty years, reconnecting with the best aspects of China's four-thousand-year-old culture while attempting to resolve the multifaceted problems confronting a nation hurtling toward world superpower status.

As postulated earlier in this essay, Mao has been the conceptual heart of contemporary Chinese art and, in a more general sense, has exerted enormous influence over Chinese society for decades. Does the spirit of Mao have to be laid to rest before Chinese culture can move on?

This conundrum is the crux of one of the most powerful and daring "portraits" of contemporary China, Sui Jianguo's *The Sleep of Reason* (2005; pls. 18–21). The installation depicts Mao sleeping (apparently peacefully) on his side, covered by a simple peasant's blanket. Its significance derives from the fact that among all of the paintings, posters, and sculptures of Mao, none show him lying down; virtually all aim to capture the vertical, larger-than-life embodiment of Mao the soldier, the leader, the "god." As Jeff Kelley wrote in 2005:

By representing Mao as the Sleeping Buddha of modern China, Sui again raises the question . . . of

whether the Chairman (and the revolution he embodied) has truly passed into history, or if he remains in a state of ideological nirvana from which he might yet arise in some transmogrified form. . . . Sui has done nothing less than intervene in the history of Mao's image, perhaps to change it forever. . . . He has returned Mao's spirit, if not his body, to the countryside, whence it came, and where it might finally come to rest.[14]

The questions raised by *The Sleep of Reason* speak directly to the disorienting crosscurrents now swirling through China as it transitions from a rigid socialist state to a far more flexible society. As is often the case, contemporary artists frame important philosophical questions in provocative visual formats meant to stimulate vigorous debate, but they seldom serve up simple answers. This is certainly the case in today's China, where artists find themselves at the vanguard of cultural change. If the pioneering styles of Political Pop and Cynical Realism have truly run their course, the challenge now facing Chinese artists is to forge a path forward in the face of dramatic social and economic evolution.

Notes

1 Gao Minglu, "Toward a Transnational Modernity," in *Inside Out: New Chinese Art*, ed. Gao Minglu (San Francisco: San Francisco Museum of Modern Art; New York: Asia Society Galleries; Berkeley: University of California Press, 1998), 21.

2 Quoted in Andrew Solomon, "Their Irony, Humor (and Art) Can Save China," *New York Times Magazine*, December 19, 1993.

3 See Lawrence Alloway, *American Pop Art* (New York: Collier, 1974).

4 Reena Jana, "Between Worlds Old and New," in *New Modernism for a New Millennium: Works by Contemporary Asian Artists from the Logan Collection* (San Francisco: San Francisco Museum of Modern Art, 1999), n.p.

5 Wu Hung, "Self and Environment," in *Reinterpretation: A Decade of Experimental Chinese Art, 1990–2000*, ed. Wu Hung with Wang Huangsheng and Feng Boyi (Guangzhou, China: Guangdong Museum of Art, 2002), 255.

6 Li Xianting, "Fang Lijun and Cynical Realism," in *Fang Lijun: Human Images in an Uncertain Age* (Tokyo: Japan Foundation Asia Center, 1996), 85.

7 Yue Minjun, in *Yue Minjun, Red Ocean*, ed. Julia Colman (London: Chinese Contemporary Art Ltd., 2000), 9.

8 Jeff Kelley, "The Face of China," in *Where Is Mao? 2000* (Bangkok: Art Center, Chulalongkom University, 2000), n.p.

9 Bernard Marcadé, "This Never-Ending End . . . ," *Flash Art*, no. 124 (October–November 1985): 39; Jack Flam, "The Alchemist," *New York Review of Books*, February 13, 1992.

10 Ai Weiwei, interview by Britta Erickson, July 14, 2006. Excerpts published in auction catalogue for *Contemporary Art Asia: China Korea Japan* (New York: Sotheby's, 2006), 137.

11 Zhai Yongming, "Another Look," in *Yu Hong* (Beijing: Long March Space, 2006), n.p.

12 Mary Jane Jacob, "In the Space of Art: Zhang Huan," in *Buddha Mind in Contemporary Art*, ed. Jacquelynn Baas and Mary Jane Jacob (Berkeley: University of California Press, 2004), 247.

13 Eleanor Heartney, "Zhang Huan: Becoming the Body," in *Zhang Huan: Altered States*, ed. Melissa Chiu (New York: Asia Society; Milan: Charta, 2007), 49.

14 Jeff Kelley, *Sui Jianguo: The Sleep of Reason* (San Francisco: Asian Art Museum, 2004), 62.

Catalogue of the Exhibition

Unless otherwise noted, all works are from
the collection of Vicki and Kent Logan.

AI WEIWEI (艾未未)
Born Beijing, 1957

Ruyi, 2006
Porcelain
5 ⅛ × 30 ⅜ × 9 in. (13 × 77.2 × 22.9 cm)
Plate 70

Colored Vases, 2007
Industrial paint and Neolithic clay
Ten pots, dimensions variable
Plates 71–72

CUI GUOTAI (崔国泰)
Born Shenyang, 1964

The Wreckage of the Train, 2006
Acrylic on canvas
70 ⅞ × 70 ⅞ in. (180 × 180 cm)
Plate 88

FANG LIJUN (方力钧)
Born Handan, 1963

Series 1, No. 3, 1990–91
Oil on canvas
31 ⅝ × 39 ⅛ in. (80.3 × 99.4 cm)
Collection of Vicki and Kent Logan, fractional and promised
gift to the San Francisco Museum of Modern Art
Plate 50

Series 1, No. 6, 1990–91
Oil on linen
39 × 39 ⅛ in. (99.1 × 99.4 cm)
Collection of Vicki and Kent Logan, fractional and promised
gift to the San Francisco Museum of Modern Art
Plate 51

Series 3, No. 15, 1993
Oil on canvas
71 × 102 in. (180.3 × 259.1 cm)
Collection of Vicki and Kent Logan, fractional and promised
gift to the San Francisco Museum of Modern Art
Plate 53

980815, 1998
Oil on canvas
98 ⅜ × 141 ¾ in. (249.9 × 360.1 cm)
Collection of Vicki and Kent Logan, fractional and promised
gift to the San Francisco Museum of Modern Art
Plate 52

GU WENDA (谷文达)
Born Shanghai, 1955

united nations—babel of the millennium, 1999
Hair, glue, and rope
Ten of 116 panels, each: 78 × 48 in. (198.1 × 121.9 cm)
San Francisco Museum of Modern Art, gift of Vicki and Kent Logan
Plates 94–95

LI DAFANG (李大方)
Born Shenyang, 1971

Elevator, 2007
Oil on canvas
78 ¾ × 118 ⅛ in. (200 × 300 cm)
Plate 90

Little Snow, 2007
Oil on canvas
74 ¾ × 137 ¾ in. (189.9 × 349.9 cm)
Plate 89

LI SONGSONG (李松松)
Born Beijing, 1973

The Meek Shall Inherit the Earth, 2006
Oil on canvas
78 ¾ × 141 ¾ in. (200 × 360.1 cm)
Plate 87

Someday My Prince Will Come, 2007
Oil on canvas
Two panels, overall: 98 ⅜ × 173 ¼ in. (249 × 439 cm)
Plate 86

LIN TIANMIAO (林天苗)
Born Taiyuan, 1961

Initiator, 2004
Fiberglass and silk
66 ¼ × 39 ¼ × 48 in. (168.3 × 99.7 × 121.9 cm)
Plates 96–97

Seeing Shadow No. 12, 2007
Ink and silk thread on canvas
56 ¾ × 111 ¾ in. (144.2 × 283.9 cm)
Plate 98

Seeing Shadow No. 20, 2007
Ink and silk thread on canvas
56 ¾ × 111 ¾ in. (144.2 × 283.9 cm)
Plate 99

LIU HUNG (刘虹)
Born Changchun, 1948

Where Is Mao?, 1989–2000
Graphite on canvas, wood, embroidered silk,
electric fans, and enamel
Dimensions variable
Plates 73–79, 111–12

Daughters of China, 2006
Single-channel video, 5:27 min.
Plates 80–84

We Have Been Naught, We Shall Be All, 2007
Oil on canvas
Three panels, overall: 72 × 240 in. (182.9 × 609.6 cm)
Plate 85

LIU WEI (刘炜)
Born Beijing, 1972

Two Drunk Painters, 1990
Oil on canvas
59 × 39 ½ in. (149.9 × 100.3 cm)
Collection of Vicki and Kent Logan, fractional and promised
gift to the San Francisco Museum of Modern Art
Plate 56

Swimmers, 1997
Oil on canvas
40 ½ × 40 ½ in. (102.9 × 102.9 cm)
Collection of Vicki and Kent Logan, fractional and promised
gift to the San Francisco Museum of Modern Art
Plate 57

LIU XIAODONG (刘小东)
Born Jincheng, 1963

Fat Grandson, 1996
Oil on canvas
90 ½ × 71 in. (229.9 × 180.3 cm)
Collection of Vicki and Kent Logan, fractional and promised
gift to the San Francisco Museum of Modern Art
Plate 27

Xiaomei, 2007
Oil on canvas
78 ¾ × 78 ¾ in. (200 × 200 cm)
Plate 28

SHENG QI (盛奇)
Born Hefei, 1965

My Left Hand, 2004
Bronze
14 ¼ × 4 × 3 ⅛ in. (36 × 10 × 8 cm)
Plate 103

SUI JIANGUO (隋建国)
Born Qingdao, 1956

Legacy Mantle, 2005
Automobile paint on fiberglass
One of five pieces, each: 24 ½ × 19 × 14 in. (62.2 × 48.3 × 35.6 cm)
Plate 23

Made in China, 2005
Automobile paint on fiberglass
78 ¾ × 40 × 72 ⅞ in. (200 × 102 × 185 cm)
Plate 22

The Sleep of Reason, 2005
Automobile paint on fiberglass and resin, plastic, and wood
Dimensions variable
Plates 18–21

Impermanence, 2006
Lead
10 ¼ × 6 ¼ × 7 ⅞ in. (26 × 15.9 × 20 cm)
Plate 24

WANG GONGXIN (王功新)
Born Beijing, 1960

Blind Talker, 2005
Single-channel video projection, 12 min.
Plates 33–46

XU BING (徐冰)
Born Chongqing, 1955

Bird Language, 2004
Copper, mechanical plastic bird with feathers and
audio sensor, and gravel
21 × 9 × 9 in. (53.3 × 22.9 × 22.9 cm)
Plate 32

YAN LEI (颜磊)
Born Yangfang, 1965

International Landscape (Beijing), 2001
Acrylic on canvas
51 ⅜ × 66 ⅞ in. (130.5 × 169.9 cm)
Plate 91

Super Lights—Dog Year New York, 2006
Oil on canvas
Two panels, overall: 102 ¼ × 78 ¾ in. (259.7 × 200 cm)
Plate 92

YANG SHAOBIN (杨少斌)
Born Tangshan, 1963

Untitled (1999–4), 1999
Oil on linen
Two panels, overall: 90 ½ × 141 ¾ in. (229.9 × 360.1 cm)
Denver Art Museum, promised gift of Vicki and Kent Logan
Plate 47

YIN ZHAOYANG (尹朝阳)
Born Nanyang, 1970

Untitled, 2005
Oil on canvas
79 × 118 in. (200.7 × 299.7 cm)
Plate 58

YU HONG (俞红)
Born Sian, 1966

She—White Collar Worker, 2006
Acrylic and chromogenic prints on canvas
Three panels, overall: 59 × 196 ½ in. (149.9 × 499.1 cm)
Plate 93

YU YOUHAN (余有涵)
Born Shanghai, 1943

Mao Decorated, 1993
Acrylic on canvas
46 ⅛ × 38 ¼ in. (117.2 × 97.2 cm)
Denver Art Museum, promised gift of Vicki and Kent Logan
Plate 102

YUE MINJUN (岳敏君)
Born Daqing, 1962

Ostriches, 1998
Oil on canvas
78 ¾ × 110 ¼ in. (200 × 280 cm)
Collection of Vicki and Kent Logan, fractional and promised
gift to the San Francisco Museum of Modern Art
Plate 29

The Last 5000 Years, 2000
Acrylic on fiberglass-reinforced plastic
Five figures, each: 72 ½ × 29 × 23 in. (184.2 × 73.7 × 58.4 cm)
Plate 30

Contemporary Terracotta Warriors, 2002
Acrylic on fiberglass-reinforced plastic
Five figures, each: 72 × 23 × 21 in. (182.9 × 58.4 × 53.3 cm)
Plate 31

ZENG FANZHI (曾梵志)
Born Wuhan, 1964

Meat, 1992
Oil on canvas
71 × 59 ¼ in. (180.3 × 150.5 cm)
Collection of Vicki and Kent Logan, fractional and promised
gift to the San Francisco Museum of Modern Art
Plate 49

Mask Series No. 10, 1998
Oil on canvas
70 ¾ × 78 ¾ in. (179.7 × 200 cm)
Denver Art Museum, promised gift of Vicki and Kent Logan
Plate 48

ZHANG DALI (张大力)
Born Harbin, 1963

Dialogue 11/11/99, 1999
Neon on canvas
48 × 48 × 5 in. (121.9 × 121.9 × 12.7 cm)
Plate 54

100 Chinese, 2001
Synthetic resin
Seventeen pieces, each: 11 ¾ × 9 ⅞ × 9 ⅞ in. (29.9 × 25.1 × 25.1 cm)
Plate 55

ZHANG HUAN (张洹)
Born Anyang, 1965

Buddha Never Down, 2003
Metal and fiberglass
83 × 83 × 83 in. (210.8 × 210.8 × 210.8 cm)
Plate 104

Buddha Finger (10), 2006
Copper
20 ½ × 24 ⅜ × 108 ⅜ in. (52.1 × 61.9 × 275.9 cm)
Plate 106

Yang Hucheng, 2007
Incense ash, charcoal, and resin on canvas
98 ⅜ × 63 in. (249.9 × 160 cm)
Plate 105

ZHANG XIAOGANG (张晓刚)
Born Kunming, 1958

Big Family, 1996
Oil on linen
57 × 61 in. (144.8 × 154.9 cm)
Collection of Vicki and Kent Logan, fractional and promised
gift to the San Francisco Museum of Modern Art
Plate 26

Untitled, 2005–6
Oil on canvas
98 ⅜ × 118 ⅛ in. (249.9 × 300 cm)
Plate 25

ZHENG LI (郑力)
Born Chongqing, 1976

Little Church, 2004
Oil on canvas
78 ¾ × 59 in. (200 × 149.9 cm)
Plate 101

Same Way, Different Direction, 2004
Oil on canvas
59 × 59 in. (149.9 × 149.9 cm)
Plate 100